T0351451

A
Shakespearean
Botanical

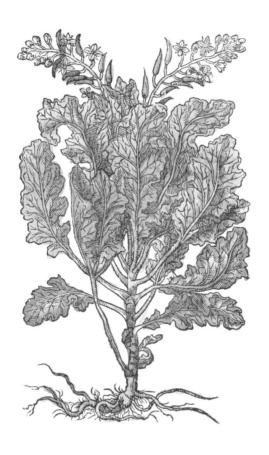

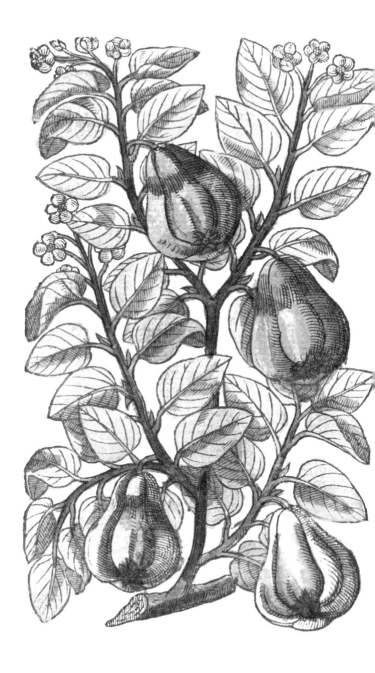

A
Shakespearean
Botanical

MARGARET WILLES

Bodleian Library
UNIVERSITY OF OXFORD

First published in 2015
by Bodleian Library Publishing
Broad Street
Oxford OX1 3BG

www.bodleianshop.co.uk

2nd impression 2016
3rd impression 2020
4th impression 2024

ISBN 978 1 85124 437 9

Text © Margaret Willes, 2015

Images, unless specified, © Bodleian Library,
University of Oxford, 2015

Cover design by Dot Little at the Bodleian Library
Designed and typeset in 11 on 15 Monotype Janson
by illuminati, Grosmont

Printed and bound in China by C&C Offset Printing Co., Ltd.
on 115 gsm Chinese YuLong paper

MIX
Paper | Supporting
responsible forestry
FSC® C008047
www.fsc.org

British Library Catalogue in Publishing Data
A CIP record of this publication is available from the British Library

FRONTISPIECE ILLUSTRATIONS
p. i *Cabbage*, p. ii *Quince*, p. vii *Carnation*,
p. viii *Anemone*, all from Gerard's *Herball*

Contents

❧

Acknowledgements

I have been deeply impressed at Shakespeare's knowledge about plants, as in so many areas. I would like to thank those whose expertise has helped me in my journey of discovery: Dr Stephen Harris for answering my botanical queries; and Marinita Stiglitz for her opinion on the illustrations in the Bodleian Library's precious herbal. Bruce Alexander is not only a fine actor but steeped in knowledge about Shakespeare's plays. Last, but not least, I am grateful to Dr Samuel Fanous for letting me write this book.

Anemone coccinea multiplex
Double scarlet Winde flower

Introduction

William Shakespeare may be a man of mystery in many ways, but it is clear from his works that he was familiar with a wide range of botany: flowers, herbs, fruit and vegetables. Moreover, he recognized the important role that plants played in the daily life of Tudor England.

> O mickle is the powerful grace that lies
> In herbs, plants, stones, and their true qualities,
> For naught so vile that on the earth doth live
> But to the earth some special good doth give;
>
> *Romeo and Juliet*, II.2.15–18

Friar Laurence is talking here particularly about the power of nature to heal as well as harm. The plot of the romantic tragedy of *Romeo and Juliet* turns on drugs and poisons that can be derived from herbs – in this case belladonna, or deadly nightshade, and aconite, or monkshood. In his quest for aconite, Romeo takes us into the interior of an apothecary's shop. It is set in Mantua, but it could equally be found on a street in London. Romeo describes a rather down-at-heel apothecary:

> And hereabouts a dwells, which late I noted,
> In tattered weeds, with overwhelming brows,
> Culling of simples. Meagre were his looks.
> Sharp misery had worn him to the bones,

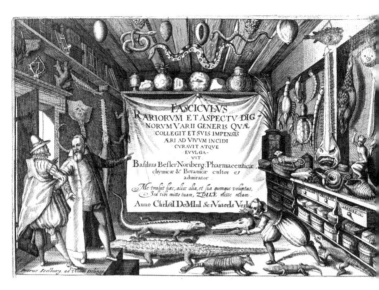

The interior of the cabinet of curiosities belonging to Basil Besler, a Nuremberg apothecary, from the title page of his *Fasciculus rariorum*, published in 1616. By no means down-at-heel, it nevertheless shows some of the contents that Shakespeare attributes to his Mantuan apothecary.

> And in his needy shop a tortoise hung,
> An alligator stuffed, and other skins
> Of ill-shaped fishes; and about his shelves
> A beggarly account of empty boxes,
> Green earthen pots, bladders, and musty seeds,
> Remnants of packthread, and old cakes of roses
> Were thinly scattered... V.1.38–48

The apothecary's dried cakes of rose petals are a reminder that flowers were useful as well as ornamental. Shakespeare introduces a plethora of flowers, wild and

cultivated, native and exotic. Roses in particular appear in his sonnets, associated with beauty and love. Thus in Sonnet 54:

> The rose looks fair, but fairer we it deem
> For that sweet odour which doth in it live.

In Sonnet 99 he teams the rose with the lily and the herb sweet marjoram, all fragrant and used in garlands and bouquets:

> The lily I condemnèd for thy hand,
> And buds of marjoram had stol'n thy hair;
> The roses fearfully on thorns did stand,
> One blushing shame, another white despair;
> A third, nor red nor white, had stol'n of both,

Perhaps his most famous lines come in Sonnet 18, where he may be talking of flowers in general, or specifically hawthorn:

> Shall I compare thee to a summer's day?
> Thou art more lovely and more temperate.
> Rough winds do shake the darling buds of May,

Although the sonnets contain botanical references, I have decided in this book to take my quotations from Shakespeare's plays and his two long poems, *The Rape of Lucrece* and *Venus and Adonis*, as they enable me to provide social background to the lines. In *The Winter's Tale* a whole scene, the fourth of Act IV, is devoted to

I *Lauandula flore cæruleo.*
Common Lauander ſpike.

Lavender from Gerard's *Herball*. He advised that the extracted oil could be powerful, warning against 'divers rash and overbold Apothecaries, and other foolish women' who made it too strong. Shakespeare must have been aware that lavender, having time to mature through spring into summer, was a 'hot herb', and thus Perdita considers it appropriate for middle age in *The Winter's Tale*.

flowers, associating their season with the ages of man. At an annual feast in July, Perdita plays the role of the Queen, garlanded like Flora. With country hospitality, she welcomes Polixenes, King of Bohemia, and Camillo, one of the Lords of Sicilia, offering them rosemary and rue, herbs that keep fresh in winter. When Polixenes suggests that they are thus suitable for old men, Perdita points out that there are comparatively few flowers blooming in July. We have to remember that until the arrival of exotic flowers from different parts of the world, such as South America, the Far East and the southern part of Africa, there were few flowers in the garden beyond midsummer. Those that were available, such as carnations, were called gillyflowers or July flowers. In an intriguing speech, Perdita says she doesn't like these carnations, because she will not improve on nature. Shakespeare's reference to nature's bastards seems to indicate that he was familiar with the artistry, or more accurately science, of florists who bred up varieties to achieve certain colours and patterns to the petals.

Nevertheless Perdita finds the proper floral tributes for middle age:

Hot lavender, mints, savory, marjoram,
The marigold, that goes to bed wi'th' sun,
And with him rises, weeping. These are flowers
Of middle summer...

The Winter's Tale, IV.4.104–107

She then goes on to lament that she cannot provide spring flowers, primroses, daffodils, violets, oxlips, lilies for Florizel, son of Polixenes, and the Shepherdess. Although this part of the play is set in Bohemia, Shakespeare is invoking the kind of pastoral festivities that took place in English summers.

Another play where a wide range of flowers is introduced, along with herbs, is *Hamlet*. Ophelia, out of her mind with grief at the death of her father Polonius and rejection by Hamlet, makes a startling appearance in the fifth scene of Act IV: an eighteenth-century editor added the stage direction, 'fantastically dressed with straws and flowers'. The distracted girl provides a list of plants to strew over her father's grave, such as rosemary, which traditionally was scattered at funerals. In a later scene, Queen Gertrude has to report the death of Ophelia by drowning, fantastically garlanded with native meadow plants – crow-flowers, nettles, daisies and orchids known as long purples.

The sixteenth-century flower garden might become bare with autumn, but the orchard then came into its own. In his writings, Shakespeare introduced all kinds of orchard fruits, as well as berries and nuts from the hedgerow. In *Richard II* he focuses on apricots. Brought to England in the early sixteenth century, they would in fact not have been known by the Plantagenet king and his court, but Shakespeare's concern here is the

role of the orchard. Manuals of husbandry published in Tudor England make clear that a fruitful orchard was accounted the mark of an orderly and prospering household, and that the practical tasks involved in the cultivation of fruit were an appropriate occupation for gentlemen. The diplomat and scholar Sir Thomas Smith was described as 'employing his own Hands sometime for his version in grafting and planting'.[1]

The orchard in *Richard II* presents a metaphor for the kingdom, neglected at its peril. The gardener, regretting the wasteful king, talks almost like a manual for the cultivation of fruit:

> O, what pity is it
> That he hath not so trimmed and dressed his land
> As we this garden. We at time of year
> Do wound the bark, the skin of our fruit trees,
> Lest, being over-proud in sap and blood,
> With too much riches it confound itself.
> Had he done so to great and growing men,
> They might have lived to bear, and he to taste,
> Their fruits of duty...
>
> Act III.4.56–64

References to vegetables in Shakespeare are comparatively rare, and almost all appear in *The Merry Wives of Windsor*. The introduction of a Welsh parson, Sir Hugh Evans, enables Shakespeare to play with Latin and English, with puns about carrots and cabbages. Mistress Ford memorably compares Sir John Falstaff to a gross

watery pumpkin, while the fat knight calls upon the heavens to rain potatoes, considered an aphrodisiac at the time, when he prepares to meet Mistress Ford in Windsor Great Park. Shakespeare must have equated the earthy vegetables with the bawdy tone of the play, and its essentially middle-class cast.

Turning to Shakespeare's possible sources for his plants, we know that he was born in Stratford-upon-Avon and must have had the opportunity to roam the Warwickshire countryside. This background is reflected in the local names he gave to some of the meadow flowers: in *A Midsummer Night's Dream* he calls the wild pansy 'love-in-idleness'; in *Love's Labour's Lost* the buttercup is referred to as 'cuckoo-buds'. By 1564 England had officially become a Protestant nation, though only just, for Henry VIII had made the break with Rome in the 1530s and Mary Tudor had returned it to the Catholic faith in the 1550s. Many memories of the old faith come through in the names of plants, such as 'herb of grace' for rue, and associations with the Virgin Mary in the marigold, or 'Mary gold' and the columbine, which had 'Our Lady's Shoes' as one of its many alternative names.

Shakespeare must have taken much of his wide knowledge of plants from books. Ben Jonson famously wrote that Shakespeare had 'small Latin and less Greek', so if he consulted herbals they were likely to have been in

English. The first truly Renaissance herbal in English was written by the botanist William Turner, a fervent Protestant who spent many years in exile in Europe on account of his beliefs. In 1551 he published the first part of a *New Herball*, in a small folio format, with 196 pages running from *A* to *P* with headings in English, but the plants arranged according to the initial of the Latin names. Unfortunately this little book was let down by the quality of the production, with many of the illustrations reversed and missing captions: this was an important consideration, for herbals were providing vital information. With the death of the Protestant Edward VI and accession of the Catholic Mary Tudor in 1553, Turner fled abroad and published his follow-up volumes in Cologne. Only in 1568 was the complete work updated and reissued in London, with a dedication to Elizabeth I. Turner, 'the Father of English Botany', died the following year and a decade was to pass before another herbal in the vernacular appeared. In 1578 Henry Lyte, a Somerset knight, Oxford-educated, travelled in Europe to develop his knowledge of plants. His *Historie of Plants*, based on a translation of a French herbal, also offered elegant illustrations. Having images of plants was very important, for it enabled the reader to secure accurate identification, a vital factor in gardening, cooking and medicine.

When Shakespeare arrived in London, books would have provided him with all manner of sources for his

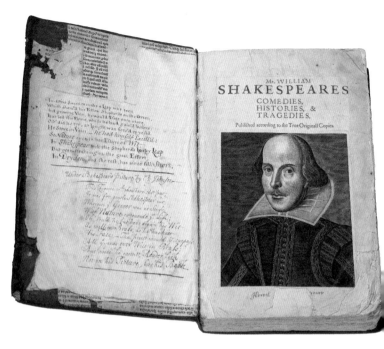

Martin Droeshout's portrait of William Shakespeare from the title page of the First Folio edition of his plays. This was published in 1623, seven years after the playwright's death, edited by his fellow actors and friends John Hemmings and Henry Condell, and published by Isaac Jaggard and Edward Blount.

plays. A friend from Stratford-upon-Avon, Richard Field, was apprenticed to the Huguenot printer and bookseller Thomas Vautrollier, based in Blackfriars. With Field, Shakespeare probably explored the shops and stalls of St Paul's Churchyard, the centre of the English book industry. In 1593 it was Field who published his poem *Venus and Adonis*.

In 1577 Henry Byneman, whose shop was located by the north-west door of the cathedral, published Holinshed's *Chronicles of England, Scotland, and Ireland*, one of Shakespeare's sources for his history plays. For the plays set in classical times, he drew on Sir Thomas North's translation of Plutarch's *Lives*, produced by Vautrollier. Between 1565 and 1577, Arthur Golding worked on his translation of Ovid's *Metamorphoses*, which Shakespeare drew upon both for classical allusions and legends about the origins of plants, such as laurel, daphne and the narcissus. For detailed botanical information he could use the works of Turner and Lyte, and, after 1597, the massive herbal of John Gerard.

John Gerard was born in Cheshire in 1545, attending school at Willaston near Nantwich, where he learnt Latin and possibly some Greek before being apprenticed to a London barber surgeon. At a date unknown, he became supervisor of the gardens of William Cecil, Lord Burghley, the queen's chief minister. Cecil's gardens included Burghley in Cambridgeshire, Theobalds in Hertfordshire, and the garden attached to his London house on the Strand. All these were in the vanguard of design in England, with elaborate parterres and garden buildings. Cecil also had access, through his high office, to the latest exotic plants coming from Europe and from the Middle East. Gerard had his own garden in Holborn, publishing a catalogue of its contents in 1596.

Also at a date unknown, John Gerard was asked to take over a major publishing project, a translation of a history of plants by the Flemish herbalist Rembert Dodoens, at the death of the original translator. Dodoens's text ran to over 800 pages in a large folio format, and Gerard must have laboured long and hard on the work. The publisher was John Norton, who with his cousin Bonham was one of the wealthiest booksellers in St Paul's Churchyard, and thus able to bear the considerable costs involved. Twice a year John Norton attended the great book fair in Frankfurt, and he used his contacts there to rent from a German publisher nearly all the 1,800 woodcut blocks required. Some new ones had to be specially cut, such as a picture of the potato, which had been brought to England by Sir Francis Drake in 1586.

Rather late in the day, but luckily before printing had begun, botanist friends pointed out to Norton that Gerard was making mistakes, both in his text and in his identification of the illustrations. As a result, Matthias de L'Obel, a distinguished botanist from Lille, checked through the text, undertook editorial revisions and corrected the placing of the pictures, claiming that he had to make over a thousand alterations. A literary spat ensued, for Gerard was furious, protesting that a foreigner should not be interfering with his work, especially as English was not L'Obel's first language.

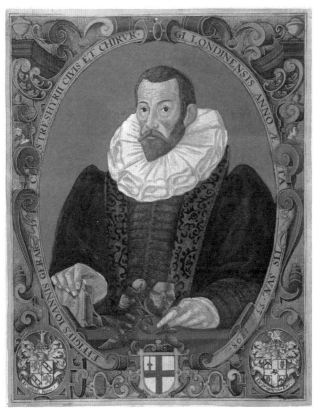

The portrait of John Gerard in his famous herbal of 1597. He is shown holding his botanical 'scoop', a potato plant from Virginia.

He may also have felt that he was being patronized as a 'mere' barber surgeon by university-trained physicians and botanists, in the complex pecking order of the medical world at the time. But Norton was put in a difficult

Carum, siue Careum.
Caruwaies.

The illustration for caraway in Gerard's *Herball*. The seeds are traditionally teamed with apple, as shown by Shakespeare in *Henry IV, Part* 2 when Justice Shallow invites Sir John Falstaff to 'see my orchard, where, in an arbour, we will eat a last year's pippin of my own grafting, with a dish of caraways' (V.3.1–3).

position, for inaccuracies and wrong identifications were potentially dangerous.

It is difficult now to work out the rights and wrongs of the quarrel, for L'Obel was not an easy character, and was later to lose his job as supervisor of a famous botanical garden in Hackney because he was accused by the owner of removing plants. However, when Gerard's book duly appeared in 1597 as *The Herball or Generall Historie of Plantes*, it was a huge and enduring success, becoming one of the most famous botanical works in English. John Gerard did not merely produce a translation from the Latin, but used his talent for writing beautiful prose that sometimes verged on the lyrical. This is his description of the sunflower, a sensational introduction from the New World that he called the 'Marigolde of Peru':

> This great flower is in shape like to the Cammomill flower, beset rounde about with a pale or border of goodly yellowe leaves, in shape like the leaves of the flowers of white Lillies: the middle part whereof is made as it were of unshorne velvet, or some curious cloth wrought with a needle, which brave worke, if you do thoroughly view and marke well, it seemeth to be an innumerable sort of small flowers, resembling the nose or nozell of a candle-sticke, broken from the foote thereof.[2]

Scholars of herbals have no doubt that Shakespeare used Gerard's book as a botanical reference. He must

have appreciated that here he had a master of prose. John Gerard, moreover, may have known the playwright, for in his account of the buttercup, which he calls the butterflower, he mentions finding a double form while walking to 'the Theatre' with a botanist friend. The capitalization suggests that he is talking about The Theatre, located in Shoreditch. Here James Burbage put on plays that possibly included Shakespeare's *Henry VI*, *The Comedy of Errors* and *Romeo and Juliet*, before the structural materials from the playhouse were carried under cover of night across the Thames to Southwark in 1597.

However in 2015, just before this book went to press, a new theory was presented by Mark Griffiths, who is both a botanist and a historian. He suggests that John Gerard and William Shakespeare knew each other well, as they were both protégés of Lord Burghley. He believes that the title page of Gerard's herbal is a cipher, and that the four figures depicted are not stereotypical figures such as classical botanists that were conventionally depicted in herbals of this period, but actual people. Indeed, when Gerard's herbal was reissued with emendations by an apothecary, Thomas Johnson, in 1633, the title page was embellished with figures of Theophrastus and Dioscorides. But Griffiths proposes that this does not apply to the 1597 edition. Instead he identifies them as, on the left, John Gerard and William Cecil,

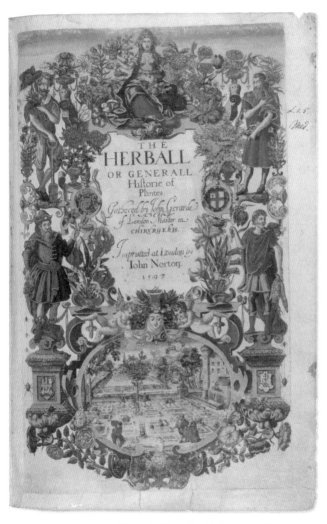

The elaborate title page of Gerard's *Herball*, with Flora presiding over a group of gardeners carrying a variety of plants and vegetables, pinks, sunflowers, and two kinds of fritillary, the crown imperial and the snakeshead. At the foot of the page is a garden with raised beds.

Lord Burghley, and on the right, Rembert Dodoens, the Flemish herbalist whose work formed the basis of Gerard's text, and William Shakespeare as a young poet, with a laurel wreath adorning his brow.

The idea of a youthful portrait of Shakespeare has roused great excitement and controversy, which will continue to rage, as does any new theory about the Bard. However, the argument can also be regarded as fascinating from the botanical point of view, for it suggests that Shakespeare became acquainted with great gardens and knowledgeable gardeners early in his career, from at least the early 1590s. On the title page, the figure that is suggested as Shakespeare is shown holding a snakeshead fritillary. In his long poem *Venus and Adonis*, Shakespeare writes of a flower that springs from the blood of Adonis after he has been killed by a boar:

> And in his blood that on the ground lay spilled
> A purple flower sprung up chequered with white,
> Resembling well his pale cheeks, and the blood
> Which in round drops upon their whiteness stood.
> (1165–1170)

Traditionally the purple flower to which Shakespeare refers has been identified as the anemone, for that was the flower that Ovid used in his *Metamorphoses* when he described how Venus created it from nectar. It was also the flower that Arthur Golding had in mind when

he translated Ovid's work in the 1560s. He had Venus
sprinkling nectar on the ground:

> And before that full an hour expirèd were,
> Of all one colour with the blood a flower she there
> did find
> Even like the flower of that same tree whose fruit
> in tender rind
> Have pleasant grains enclosed.[3]

The flower here described is all of one colour and
resembles fruit blossom, which applies to the anemone.
Golding goes on to talk of how every blast of wind
shakes the blossom so that it is short-lived, which is why
the anemone is often called the wind flower.

Although Shakespeare almost certainly used
Golding's translation when he composed *Venus and
Adonis*, his description of the flower does not fit the
anemone, but rather the snakeshead fritillary, with its
distinctive purple and white chequered pattern. Why
did Shakespeare change the flower, and where did he
get his information? *Venus and Adonis* was the first of
his works to be published, appearing in 1593, four years
before Gerard's *Herball*. There has been debate among
botanists as to whether this fritillary is native to Britain.
It was not recorded as growing in the wild until 1736,
when it was found in fields near Ruislip in Middlesex.
It was first recorded in France in the 1550s growing in
the valley of the Loire. Gerard records in his herbal

that it was found 'between Orleance and Lions … from whence they have been brought into the most parts of Europe'.[4] His plants were given to him by French royal gardener Jean Robin. The snakeshead fritillary is not included by either William Turner or Henry Lyte in their herbals. Shakespeare could have found out about the plant from the herbal of Rembert Dodoens, *Stirpium Historiae Pemptades Sex*, but given his lack of familiarity with Latin, it would seem more likely that he gained his information from Gerard, who not only had a copy of Dodoens, but also the flowers growing in his garden, inspiring the poet to replace the convention of the anemone by the fritillary.

The snakeshead fritillary is just one of a series of plants featured on Gerard's title page that Griffiths has connected with Lord Burghley. At the bottom of the page is an illustration of a formal garden, which he suggests is derived from an engraving by the Dutch artist Adriaen Collaert of 'April', that has been made to look like part of the formal gardens at Theobalds in Hertfordshire, with the addition of an olive tree which records show was grown by Lord Burghley. However, an identical engraving, complete with olive tree, appears in reversed form in a book produced contemporaneously by the German publisher, Nicolaus Basseus, who supplied John Norton with most of the woodcuts for Gerard's plant illustrations.[5] If this is not the garden at

Theobalds, but a stock illustration, then Griffiths' claim that it shows the Queen being shown round by Gerard (an unlikely scenario given the strict social hierarchy of Tudor England) is cast into doubt.[6]

The title page of Gerard's herbal was engraved in copper-plate by the artist William Rogers, who also provided a portrait of the herbalist holding in his right hand a book, and in his left a spray of the potato plant, his botanical 'scoop'. So proud was John Norton of the book that in 1601 he gave a copy to Sir Thomas Bodley for the library that he was planning in Oxford. For this copy all the woodcut illustrations of the plants were coloured by artists – a considerable undertaking, for there were 1,800 images. Samples of the plants would have had to be collected in season, for the illustrators to copy. According to one of the Bodleian Library's experts, the hand colouring has been executed quite roughly and quickly, with the paint layer going beyond the contours of the woodcuts, with simple ways of creating a three-dimensional effect. Therefore these were probably not undertaken by professional limners. Maybe a team of women and children were employed in the task. Despite the understandable haste shown, the illustrations are very beautiful.

Although the herbal does show signs of having been consulted heavily through the centuries, the colours of the images have not deteriorated from exposure to light.

But the different shades used to create the foliage have at times turned from green to turquoise, probably as a result of copper in the pigments.

The copy of the herbal that I have used to provide the images that accompany the entries chosen for this book is one of the great treasures of the Bodleian Library. It is therefore tragic that, at some time in the 1980s, the title page and portrait of Gerard were cut out of the book by an unknown 'reader'. Very fortunately, colour transparencies had been taken of these two pages, and are reproduced here.

There is an interesting coda to the story of this book. On 6 May 1603, Thomas Bodley wrote to his librarian, Thomas James, asking him to return the herbal to him so that he could send it on to Norton, who had a 'very special use' for it, adding 'howbeit I shall be assured of another as good, or rather better'.[7] The 'special use' would seem to be that Norton wanted to present it to the new king, James I, who was to arrive in London on 7 May. In the 1590s Norton had set up as a bookseller in Edinburgh, and seems to have enjoyed the King's favour there, and would certainly seek to continue this relationship. However, the copy of the herbal in the royal library is only part-coloured, and would seem to have entered the collection at a later date. Thomas James must have stuck to his guns, and refused to part with the precious herbal from the Bodleian collection.

Shakespeare and Gerard were writing at a time when book publishing in English was burgeoning. The market, especially in London, was increasing with the growth in the middle classes, who had money, some literacy and an appetite for information. In 1595 an enterprising bookseller named Andrew Maunsell set out to collect the titles of books 'either written in our owne tongue, or translated out of any other language' on a whole range of subjects that he thought would provide a useful guide to customers. A significant proportion are divinity books, but the second part of the catalogue is devoted to 'Mathematics, Physicall and Chirurgicall', which include gardening and husbandry titles. Some of these provide valuable background information on the social context of Shakespeare's references.

Gardening was one area of marked growth. The first book in English to deal with gardening in general was *A most briefe and pleasaunte treatise, teachying how to dresse, sowe and set a garden*, written by Thomas Hill and published around the year 1558. Hill described himself as a Londoner, modestly educated, with some knowledge of Latin and Italian. His first little book was adorned only with a crude woodcut of a formal garden, but when his third horticultural book, *The Gardeners Labyrinth*, was published posthumously in 1577, the text was much more sophisticated, as were the engravings, which may have been imported from the Continent. Hill provided

An illustration from Thomas Hill's *Gardeners Labyrinth* of 1577 showing a garden laid out in parterres. The owners look on as one of the gardeners operates a stirrup pump in a tub to keep the beds well watered.

the aspiring middle classes with information on how to lay out their parterres, to plant arbours and pleached alleys, and how to maintain them.

Sir Hugh Platt stands out as a remarkable figure. The son of a rich London brewer, he was able to devote his time to writing. Beginning with moralistic and poetical works, he turned his attention to a whole range of topics from mechanical inventions to alchemy. In 1596 he wrote a treatise, *Sundrie new and Artificiall Remedies against Famine*, as a result of the series of harvest failures that had hit England (see p. 62). In this he explored various

substitutes for conventional bread flours, such as meal from carrot and parsnip. A decade later he turned his attention to gardening, producing *Floraes Paradise*. It is interesting that although the book was in English, the title should be in Latin, possibly to add authority. All kinds of ingenious ideas are laid out in the book, including sprinkler systems for water boxes, and a 'growing banquet' of flowers that had been candied.

One of the most successful gardening books of the early seventeenth century also took paradise as its title: John Parkinson's *Paradisi in Sole*, a pun on his name 'park in sun', published in 1629. An apothecary based in London, he provided a compendium of practical advice along with detailed descriptions of flowers and herbs. His contemporary who concentrated on the cultivation of the orchard was William Lawson, a clergyman who became vicar of Ormesby in the North Riding of Yorkshire. He published *A New Orchard and Garden* in 1618, with much advice on the grafting and care of fruit trees, but also general horticultural information.

While these authors were aiming their books at the wealthier echelons of society, Thomas Tusser had a more modest readership in mind. Well educated, he was obliged to abandon his career in the household of an aristocratic family thanks to the religious upheavals of the Tudor period and take up farming in Suffolk. His first manual, *A Hundreth Good Pointes of Husbandrie*,

A
NEW ORCHARD
and Garden:

OR

The beſt way for planting, grafting, and to make *any ground good, for a rich Orchard : Particularly in the North,* and generally for the whole kingdome of *England,* as in nature, *reaſon, ſituation, and all probabilitie, may and doth appeare.*

With the Country Houſewifes Garden for herbes of common vſe, their *vertues, ſeaſons, profits, ornaments, varietie of knots, models for trees, and* plots for the beſt ordering of Grounds and Walkes.

AS ALSO

The Husbandry of Bees, with their ſeuerall vſes and annoyances, all being the experience of 48. yeeres labour, and now the ſecond time correcᵗed and much enlarged, by *William Lawſon.*

Whereunto is newly added the Art of propagating Plants, with the true ordering *of all manner of Fruits, in their gathering, carrying home, and preſeruation.*

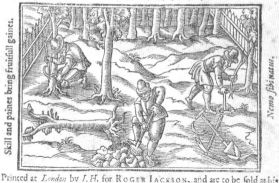

Printed at *London* by *I. H.* for ROGER IACKSON, and are to be ſold at his

Title page of William Lawson's *A New Orchard*, published in 1618. The woodcut illustration shows gardeners at work in the orchard, making and planting grafts.

first appeared in 1557. This was developed and enlarged five years later with the addition of 'a hundred good poyntes of huswifery', and further expanded in 1573 as *Five Hundreth Pointes of Good Husbandrie.*

Tusser's books proved both popular and long-lasting, still being used as reference in the nineteenth century. They are written in simple verse, with rhyme and alliteration to make them easier for even the unlettered to retain the information. His advice on gardening, particularly for women, marks a significant departure, for although women had been cultivating their gardens for centuries, there was little recognition of this in books. It transpired that the new way forward was a cul-de-sac, for women were rarely catered for in books in the future, with William Lawson's *Country Housewife's Garden* of 1626 a rare exception. Tusser's advice to housewives begins:

> In Marche, and in Aprill, from morning to night:
> in sowing and setting, good huswives delight.
> To have in their gardein, or some other plot:
> to trim up their house, and to furnish their pot.[8]

Other authors took over the task of providing advice once the pot had been furnished, again aiming their books at the middle-class housewife. *A proper newe Booke of Cokerye* was published in 1557. This is anonymous, while the next book in the genre, *A Booke of Cookrye*, merely has A.W. on the title page. Thomas Dawson, when he produced his *Good Huswifes Jewell* in 1596, would seem to have purloined some of A.W.'s recipes, a common practice of the time, and added medicinal recipes.

Although printed cookery books were available, many women kept their own collections of receipts. One manuscript household book, dated 1604 on the flyleaf, has survived. It was kept by Elinor, Lady Fettiplace, giving the kind of recipes and remedies produced by well-born ladies. Very unusually, she also provides some information about her horticultural activities in her garden at Appleton Manor in Berkshire. Many of her recipes are for what was described as 'banqueting stuffe'. In the sixteenth century, dinner consisted of two courses, the dishes for each of these laid out together on the table, in the style still adopted in Chinese meals. For special occasions in wealthy households a third course, the banquet, might be served, either at the table or in a separate room or even a separate building, a banqueting house set in the garden. The dishes for the banquet were usually very sweet, served with dessert wine. When Titania commands her fairies to serve Bottom the weaver with exotic fruits such as apricots, figs and mulberries in *A Midsummer Night's Dream*, she is indulging him with 'banqueting stuffe'. In *Romeo and Juliet*, when Lady Capulet is sorting out the dishes for her daughter's wedding banquet, she tells the Nurse to get spices, dates and quinces to be baked in a pie.

The consumption of raw fruit was regarded with much suspicion in Tudor times, as John Gerard makes clear in his herbal. Again and again he talks of how

1 *Eryngium cæruleum.*
Blew Sea Holly.

Sea holly or eryngo from Gerard's *Herball*. The root was candied to provide a sweetmeat to be eaten during the banqueting course of a meal. As a recent arrival in Britain, it was also considered an aphrodisiac.

difficult it is to digest fruit, recommending instead that they be cooked and made into tarts, or marmalade. Apples and pears in particular were the subject of much concern, and were therefore baked long and hard in pastry cases, known as coffins, with sugar, spices and saffron added.

Shakespeare's works enjoyed a revival when the great actor David Garrick organized festivities that took place over several days in 1764 at Stratford-upon-Avon to celebrate the two-hundredth anniversary of the playwright's birth. At this time, the fashion in gardening was the landscape style, as practised by Capability Brown; a century later a revival in gardening style had taken place, and formal gardens and parterres were once more laid out to adorn great houses. The cottage garden style also became fashionable, championed by William Robinson and Gertrude Jekyll. Gardeners turned to Gerard's herbal and John Parkinson's *Paradisi in Sole* to find references to old-fashioned varieties of flowers.

The Shakespearean flower garden blossomed once again. In 1878 *The Plant-lore and Garden-craft of Shakespeare* was published by Henry Nicholson Ellacombe. Canon Ellacombe is probably best known today as the author of *In a Gloucestershire Garden*, a collection of articles that he wrote for the *Manchester Guardian*, brought together as a book in 1892. His earlier book about Shakespeare's botanical references is

exhaustive, and has been a vital source for the compilation of this book. He was highly knowledgeable about plants and horticulture, avoiding the whimsicality and sentiment that overtook some of his contemporaries.

Efforts at reproducing Shakespearean gardens could all too easily descend into 'olde worlde pastiche', as E.F. Benson pointed out in his satire on the fashion. In *Queen Lucia*, published in 1920, he had Mrs Lucas (Lucia) living in a Sussex village. 'Here, as was only right and proper, there was not a flower to be found save such as were mentioned in the plays of Shakespeare.' The first bed, running below the dining-room windows, was a tribute to Ophelia:

> it consisted solely of those flowers which that distraught maiden distributed to her friends, when she should have been in a lunatic asylum. Mrs Lucas often reflected how lucky it was that such institutions were unknown in Elizabeth's day.

The second tribute was, naturally, to Perdita:

> Round the sundial, which was set in the middle of one of the squares of grass between which a path of broken paving-stones led to the front door, was a circular border, now, in July, sadly vacant, for it harboured only the spring flowers enumerated by Perdita. But the first day every year when Perdita's border put forth its earliest blossom was a delicious anniversary, and the news of it spread like wildfire through Mrs Lucas's kingdom, and her subjects were very joyful, and came to salute the violet or daffodil, or whatever it was.[9]

Benson's reservations about gardens that claimed to be Shakespearean in inspiration were echoed across the Atlantic by Esther Singleton, who published her *Shakespeare Garden* in New York in 1922. Singleton was the author of many books on furniture history and the editor of *The Antiquarian.* In disapproving terms she wrote:

> Of recent years it has been a fad among American garden lovers to set apart a little space for a 'Shakespeare Garden' where a few old-fashioned English flowers are planted in beds of somewhat formal arrangements. These gardens are not, however, by any means replicas of the simple garden of Shakespeare's time, or of the stately garden as worked out by skilful Elizabethans.[10]

One garden, however, she singled out as an accurate representation – New Place in Stratford-upon-Avon, Shakespeare's last residence.

The garden at New Place was worked upon by Ernest Law, who had written extensively on the history of Hampton Court Palace and who was a founding member of the Shakespeare Birthplace Trust. His own book about New Place, *Shakespeare's Garden*, also appeared in 1922. In this he explained how he used woodcuts from *The Gardeners Labyrinth* as a source, considering that the book must have been consulted by the playwright. Photographs show a series of knots edged by hedges of box. Within these he planted bulbs for spring display,

and annuals such as pansies and sweet williams for summer colour. Here his reference was Gerard's herbal, for he was convinced that Shakespeare knew the book. But Gerard would not have recognized the standard roses that were planted at the centre of each quarter of the parterre. These were given to the Birthplace Trust by George V and Queen Mary, so presumably could not have been refused. In fact, the photographs show that the garden has an unmistakably 1920s' feel – however determined historians are to create an accurate representation, it is inevitable that the restored garden will reflect the values and understanding of the restorers as well as being a reflection of the past.

Since the 1920s the number of Shakespearean gardens has proliferated all over the world. Examples include gardens in the Bois de Boulogne in Paris; in Central Park, New York; and in the Johannesburg Botanical Garden in South Africa, among many others. A few miles from Stratford, at Charlecote Park, the National Trust has created a Shakespearean flower border. A legend grew up after the playwright's death that in his youth Shakespeare had been caught poaching deer in the park and brought before Sir Thomas Lucy, the resident magistrate, who meted out justice. In revenge he wrote ribald verses about Sir Thomas and stuck them on Charlecote's gatehouse. Finding the neighbourhood too hot to hold him, he fled to London, paying off old

scores by bringing Lucy into two of his plays, *Henry IV, Part 2* and *The Merry Wives of Windsor* as the fussy, snobbish Justice Shallow.

Alongside the large number of Shakespearean gardens worldwide, in recent years there has been interest in Britain in re-creating sixteenth-century gardens. At Kenilworth Castle, English Heritage have replanted the Privy Garden that was laid out in 1575 by Robert Dudley, Earl of Leicester, for the visit of Queen Elizabeth I. This consists of a terrace reached by a classical loggia, from which the queen and privileged guests could look down on the pattern of the parterre. The formal knots of the parterre have been filled by appropriate plants, which set a certain challenge, for the royal visit took place in July, when, as Perdita knew well, there are comparatively few plants: the July flowers, such as carnations, pinks, stocks and wallflowers, along with roses. At Kenilworth, a nod to the future has been made with exotic imports such as the African marigold and amaranthus.

I think it highly likely that the young Shakespeare visited Kenilworth to see the festivities: it would have been the most exciting event that had taken place in the area, drawing crowds from all the surrounding towns and villages. Elements of the entertainments appear in *A Midsummer Night's Dream*, written twenty years later. But one thing is for sure: Shakespeare would not have had access to the Queen's Privy Garden.

An engraving from Crispijn de Passe's *Hortus Floridus*, c. 1614, showing a formal garden in spring. The lady is tending a bed of tulips – a late sixteenth-century introduction from the Ottoman Empire which caused great excitement when it arrived in Western Europe, but was never mentioned by Shakespeare. The garden is surrounded by arbour tunnels such as those that provided useful hiding places in *Much Ado About Nothing*.

Another meticulous garden re-creation is being undertaken by the National Trust at Lyveden New Bield in Northamptonshire. This was one of the homes of Sir Thomas Tresham, a fascinating figure. Immensely rich, and well connected, he risked both his wealth and his career as a courtier when he converted to Roman Catholicism. Tresham was a great expert on

orchards, and sent detailed instructions to his gardeners on the varieties of trees to be planted while he was imprisoned in Ely for his recusancy. As a result, a rare and detailed record has been preserved. In a letter written in 1597 to his foreman, John Slynn, Tresham suggests a 'Normandy hawksbill peare' which ripened at 'hullontide', All-hallowtide or 1 November, at the same time as a 'winter queening caterne peare' that grew near Ely and was sold in the market there. Dr Harvey's apple, he noted, kept until Candlemas, 2 February.[11] At a time when refrigeration and international imports were undreamt-of, the ripening times and lasting qualities of fruit were key. Shakespeare alludes to this when he has Sir John Falstaff compare himself to a withered apple-john, a partially desiccated apple that could last through the winter and beyond.

These, of course, are re-creations of what Esther Singleton termed 'the stately garden as worked out by skilful Elizabethans'. The 'simple gardens' of more modest members of sixteenth- and early-seventeenth-century society can be seen at the Weald and Downland Open Air Museum at Singleton in Sussex. Using Thomas Tusser's books and other sixteenth-century texts, a garden has been re-created for Bayleaf Farmstead, a yeoman farmer's house from the 1540s, along with gardens for three houses from the Stuart period. These are the kind of gardens that would have

been cultivated by Shakespeare's mother, and later
by his wife Anne Hathaway, and by the merry wives
of Windsor. All the needs of the household could
be catered for: fruit and vegetables for the kitchen;
herbs for the medicine chest; plants for dyeing, strew-
ing and brewing; and flowers to decorate the house.
Shakespeare's botanical references are not mere literary
devices; they take us to the very heart of social life in
Elizabethan and Jacobean England.

John Gerard took the Latin names for the captions to his illustrations from leading sixteenth-century European botanists such as Carolus Clusius, Pier Andrea Mattioli and Rembert Dodoens. The search was on for a universal classification of plants, but this botanical holy grail had not been achieved. In the eighteenth century the Swedish botanist Carl Linnaeus established a universal binomial system, where each species was given a genus and a species name. I have used Linnaean names when referring to specific plants.

The plants

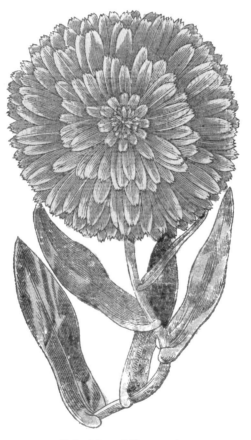

Calendula multiflora maxima
The greatest double Marigold

Aconite

Henry IV Learn this, Thomas,
And thou shalt prove a shelter to thy friends,
A hoop of gold to bind thy brothers in,
That the united vessel of their blood,
Mingled with venom of suggestion –
As force perforce the age will pour it in –
Shall never leak, though it do work as strong
As aconitum or rash gunpowder.

Henry IV, Part 2, IV.3.41–48

As *Henry IV, Part 2* draws to a close, so too does the
life of King Henry. Concerned to ensure a peaceful
succession to the throne, he urges one of his four
sons, Thomas, Duke of Clarence, to support his eldest
brother, Prince Hal, and to maintain unity within the
family.

Aconites give some of the most virulent of plant
poisons, as indicated by an alternative name, wolfs-
bane. The garden aconite is known as monkshood,
from the cowl-shaped florets, which Gerard also
likened to helmets. He made clear the danger that
these 'faire and goodly blew flowers' mask, for they
are 'so beautifull that a man would thinke they were
of some excellent vertue, but *Non est semper fides
habenda fronti*'. In other words, forget the beguiling

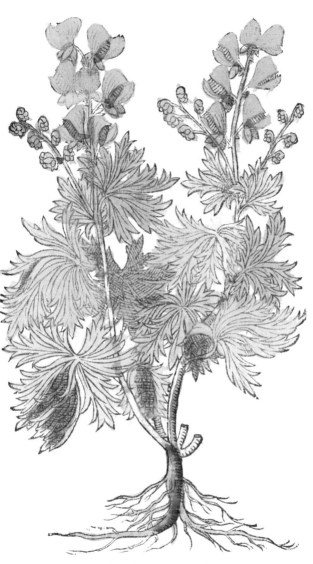

Napellus verus Caeruleus
Blew Helmet flower

attractions of the flowers, for if you take monkshood it kills you. He cited a recent incident in Antwerp where the flowers were served up in salads by ignorant persons. 'All that did eat thereof, were presently taken with most cruell symptomes and so died.'[1] The lips and tongue would swell, eyes bulge, thighs stiffen, and their wits were taken from them. Tips of darts and arrows could be coated with aconite for deadly effect.

It is almost certainly wolfsbane that Romeo takes to kill himself in *Romeo and Juliet*. Shakespeare again makes the analogy with the effect of gunpowder:

> Let me have
> A dram of poison – such soon-speeding gear
> As will disperse itself through all the veins
> That the life-weary taker may fall dead,
> And that the trunk may be discharged of breath
> As violently as hasty powder fired
> Doth hurry from the fatal cannon's womb.

V.1.59–65

This is a reminder of the vital importance of illustrated herbals like that of Gerard, both for the medical profession and for housewives responsible for the provision of medicines and ointments for their families and animals.

Apple

Falstaff I am withered like an old apple-john.

Henry IV, Part 1, III.3.4

Apples appear in a series of guises in Shakespeare's plays. The apple-john is particularly appropriate to Sir John on account not only of its name, but also its characteristic as a long-keeping fruit, an important consideration in Elizabethan times. It usually refers to the withered, partially desiccated apples kept in an apple store through the winter, remaining edible but no longer very attractive. In his *Voyages*, published in 1580, Richard Hakluyt recommended apple-johns for sailors. The reason they were called 'john' was that they were common: Tom and Jack were also added to common names to indicate that a plant was found everywhere.

In *Twelfth Night* Malvolio tells Olivia that a mysterious young man is 'Not yet old enough for a man, nor young enough for a boy; as a squash is before 'tis a peascod, or a codling when 'tis almost an apple' (I.5.151–153). Codling was a general name for a young, unripe apple. Mercutio, debating with Romeo, describes his wit as 'very bitter sweeting, it is a most sharp sauce' (II.3.74–75). Bitter-sweet was

an old variety, used in cooking rather than as table fruit, so Mercutio associates it with goose. In *Henry IV, Part 2*, Shakespeare introduces both the pippin, a long-keeping, brightly coloured apple, and the leather coat, a golden russet (V.3). And in *Love's Labours Lost*, he names one of the characters Costard, a large fruit, metaphorically described as a man's head.

Gerard in his herbal introduced several kinds of apples. The only one that coincided with Shakespeare's references was the pomewater, a large juicy fruit. In *Love's Labour's Lost* the schoolmaster Holofernes, proud of his learning and vocabulary, talks of a deer recently killed 'as you know – *sanguis* – in blood, ripe as the pomewater'. Or, to put it in straightforward language, in prime condition (IV.2.3–4).

The Latin name Gerard gave for the pomewater was *Malus carbonaria*, suggesting that it was good roasted. John Parkinson described it as 'an excellent good and great whitish apple, full of sap or moisture, somewhat pleasant sharpe, but a little bitter withall: it will not last long, the winter frosts soone causing it to rot and perish.'[3]

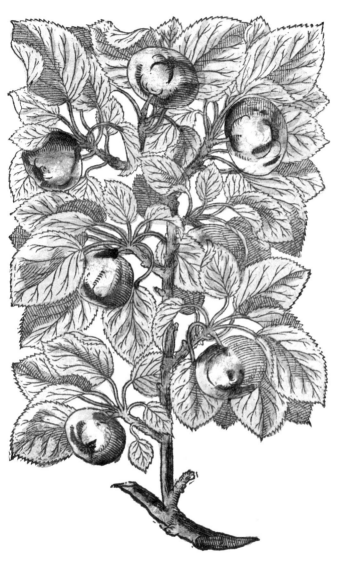

Malus Carbonaria
The Pome Water tree

Apricot

> *Gardener* Go, bind thou up young dangling apricots
> Which, like unruly children, make their sire
> Stoop with oppression of their prodigal weight.
>
> *Richard II*, III.4.30–32

These instructions, given by the gardener to his assistant, are overheard by Isabella, Richard II's queen, as she wanders in the orchard. The assistant questions why they should bother, for the whole kingdom is

> … full of weeds, her fairest flowers choked up,
> Her fruit trees all unpruned, her hedges ruined,
> Her knots disordered, and her wholesome herbs
> Swarming with caterpillars?

The connection between a fruitful orchard and an ordered family was often made in the sixteenth century, with husbandry books advising that the cultivation of fruit was an appropriate occupation for gentlemen. Here Shakespeare provides the analogy between an unkempt garden and a kingdom in disarray, with Richard overthrown by his cousin Bolingbroke, in order to restore peace and prosperity and to eradicate the King's flatterers, the 'caterpillars'. A private performance of a play titled *Richard II* was organized by the supporters of the Earl of Essex on the eve of his

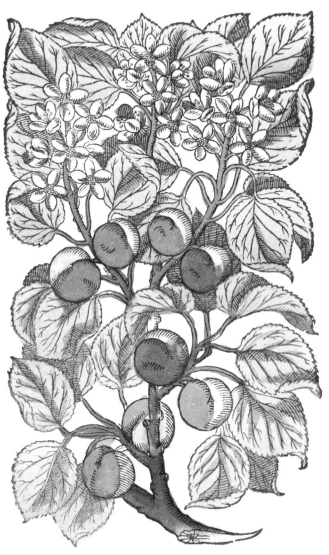

Armeniaca Malus maior
The greater Aprecocke tree

rash and fatal revolt against Elizabeth I in 1601. Some think that this was Shakespeare's drama; the alternative has been offered that it was an adaptation of a book on Henry IV by the Tudor writer John Heywood, which includes an account of the deposition of Richard II.

Shakespeare is anachronistic in his introduction of the apricot into fourteenth-century England, for it appears to have arrived some time in the early sixteenth. Its English name is a translation of the Portuguese *albricoque*, while the Latin is *Prunus armeniaca*, the Armenian peach. Although the apricot flourished in Armenia, its origin lay further east, probably Tien Shan in northern China. William Turner mentioned it in his herbal in 1548, when it was a rarity: he called it 'an hasty peach tree', while another writer thought it was a plum concealed beneath the coat of a peach.

Gerard called the fruit *aprecocke*, noting that 'These trees do grow in my garden, and now adaies in many other Gentlemens gardens throughout all England.' Uncooked fruit for the table was, however, treated with suspicion. In a book about health published in 1541 Sir Thomas Elyot warned, 'Fruites generally are noyfulle to man and do ingender ill humours.'[4] Peaches and apricots were thought not as harmful as other fruit, and Gerard recommended eating them before the meat course, to aid digestion, rather than after, when 'they corrupt and putrifie the same.'[5]

Broom

Iris Thy banks with pionied and twillèd brims,
Which spongy April at thy hest betrims,
To make cold nymphs chaste crowns; and thy broom-
 groves
Whose shadow the dismissèd bachelor loves,
Being lass-lorn;

 The Tempest, IV.1.64–68

These lines of *The Tempest* are taken from the masque
in Act IV, which Ariel has organized to celebrate the
betrothal of the young lovers Ferdinand and Miranda.
The three goddesses represented in the masque are
Juno, descending from the heavens, or the air; Iris,
the rainbow, or water; and Ceres, presenting fertility
from the earth. Iris is here calling Ceres away from
her earthly surroundings to meet and entertain Juno.
Iris's speech is curious, botanically speaking. Pion
could refer to peonies, while it has been suggested
that 'twillèd' should really be 'lilied', so that nymphs
have garlands of two of the loveliest flowers. Also
'broom-groves' is a strange reference, for broom is a
shrub rather than a tree, growing in dry pastures and
low woods.

Broom, or *planta genista*, was adopted as his badge
by Geoffrey, Count of Anjou, and inherited by his

son, Henry II, King of England. The male Plantagenet line of kings ended with the death of Richard III on Bosworth field in 1485, but Elizabeth I could claim to be a Plantagenet through her grandmother, Elizabeth of York.

Gerard described it as a shrubby plant with 'stalks or rather woodie branches', which were used for besoms, or brooms, to sweep. The 'brave yellow flowers', appearing at the end of April and May were gathered and pickled for use in salads 'as Capers be'. A recipe for pickling broom buds was included by Elinor Fettiplace in her receipt book of 1604:

> you must putt yo[r] Broome buddes as soone as you have gathered them in water and some sharpe vergis [verjuice], then lett them boyle 2 or 3 walmes then take them from the fire & putt a little salte to them powre them liccoure and all into a milcke panne, When they are through cowld strayne the liccoure from them and putt them into sharpe vergis and salte and soe keepe them all the yeare.[6]

Gerard listed several medical uses, including wine for dropsy. Henry VIII, famous for his prodigious appetites, 'was woont to drinke the distilled water of Broome flowers against surfets, and diseases thereof arising'.[7]

Genista
Broome

Cabbage

Evans Pauca verba, Sir John; good worts.
Falstaff Good worts? Good cabbage! ...

The Merry Wives of Windsor, I.1.113–114

Shakespeare employs Latin and misuses English
to comic effect in *The Merry Wives of Windsor*. Sir
Hugh Evans, as a clergyman, has knowledge of Latin,
but also a thick Welsh accent, which emerges in
this passage about the wort, or cabbage, and in mis-
understandings concerning the carrot (see p. 61).

John Gerard recorded a wide range of the colewort
family, including cauliflowers and the savoy cabbage.
The garden colewort, he wrote,

> hath many great broad leaves, of a deepe blacke
> greene colour, mixed with ribbes and lines of reddish
> and white colours. The stalke groweth out of the mid-
> dest from among the leaves, braunched with sundrie
> armes, bearing at the top little yellowe flowers: and
> after they be past there do succeede long cods full of
> round seede like those of the Turnep.

He advised that to grow them well the soil should be
'fat and thoroughly dunged and well manured'.[8]

He also reported that there was a natural enmity
between the vine and the colewort. If grown near each

Brassica vulgaris sativa
Garden Colewoort

other, the vine would perish, and so a raw colewort eaten before meat would preserve a man from drunkenness.

Worts were the indispensable part of the cottager's vegetable patch, for use in pottage, along with a little pork or bacon if these were available. But, like other vegetables, cabbages were beginning to appear on gentlemen's tables. Elinor Fettiplace in her receipt book noted the times to plant out her potherbs and vegetables in her kitchen garden.

> Sow red Cabage seed after Allhallowentide [1 November], twoe dayes after the moone is at the full, & in March take up the plants & set from fowre foot each from other, you shall have faire Cabages for the Sumer; then sow some Cabage seeds a day after the full moone in Marche, then remove your plants about Midsomer, & they wilbee good for winter.[9]

Camomile

Falstaff Peace, good pint-pot; peace, good tickle-
brain. – Harry, I do not only marvel where thou
spendest thy time, but also how thou art accompanied.
For though the camomile, the more it is trodden on
the faster it grows, yet youth, the more it is wasted,
the sooner it wears.

Henry IV, Part 1, II.5.401–406

Sir John is carousing with his boon companions, along
with Prince Hal, the heir to the English throne, in
a room in the Boar's Head Tavern on Eastcheap in
London. It is startling in such an urban scene to have
this analogy with the camomile lawn, but wonderfully
memorable.

Gardening books of the late sixteenth and early
seventeenth century made reference to camomile
being used as ground cover. William Lawson in his
New Orchard, first published in 1608, talked of 'Large
walks, broad and long, close and open, like the Tempe
Groves in Thessalie, raised with gravell and sand,
having seats and banks of Camomile.' When crushed,
the herb exuded a fruity scent, like apples, and 'all
this delights the minde, and brings health to the
body'.[10] The fashion for camomile lawns was revived in
the twentieth century.

Gerard explained that 'the common Cammomill hath manie weake and feeble braunches trailing upon the grounde, taking holde upon the top of the earth, as it runneth, whereby it greatly increaseth.' He pointed out that the plants, growing in gardens, could not only be used as a fragrant ground cover, but also for profit as a medicinal plant. A whole list of uses followed: against colic and the stone and encouraging urine. It could be mixed in wine to get rid of wind and belchings, boiled in a posset wine to help children with ague. The oil from the leaves could ease aches and pains, bruises, 'shrinking of sinewes, and colde swellings'.[11]

Chamæmelum
Cammomill

Carnation

Perdita … the fairest flowers o'th' season
Are our carnations and streaked gillyvors,
Which some call nature's bastards. Of that kind
Our rustic garden's barren, and I care not
To get slips of them. …

 For I have heard it said
There is an art which in their piedness shares
With great creating nature.

The Winter's Tale, IV.4.81–88

This is a remarkable speech, for in it Shakespeare
is hinting that plants have a sexuality just as much
as animals. It is remarkable because the scientific
establishment only began to consider this sixty years
later, when Nehemiah Grew published his *Anatomy of
Plants* in 1672.

When living in London in the 1590s, Shakespeare
may well have made the acquaintance of the silk
weavers of Shoreditch, Huguenot refugees from the
Low Countries, whose passion was for breeding up
certain kinds of plants, such as tulips and carnations.
These gardeners, later to be known as florists, particu-
larly appreciated multicolours and strong markings in
their flowers, such as streaks and flames. But care had
to be taken about how to explain these phenomena.

Caryophyllus multiplex
The double Clove Gilloflower

Even in the early eighteenth century, when Thomas Fairchild, a nurseryman in Hoxton in East London, discovered that he had mated a carnation with its cousin, a sweet william, to create a plant of 'middle nature' which he called Fairchild's Mule, he had to finesse that discovery lest he be accused of tampering with God's work. No wonder Shakespeare merely hinted.

Perdita talks of the flowers of different seasons. The carnation was known as the gillyvor, or July flower, because it bloomed in July, late in the flowering season; it was only with the arrival of exotic flowers such as the dahlia and the chrysanthemum that a garden could be full of colour in autumn. It was part of a large family that also included the pink and the sweet william, and Gerard noted its many alternative names, such as 'Pagiants' and 'Sops in wine'. It is, in fact, a distant relation of the clove, and could be added to wine to impart the distinctive spicy flavour.

Carrot

Evans What is the focative case, William?
Page O – *vocativo*, O –
Evans Remember, William, focative is *caret*.
Mistress Quickly And that's a good root.

The Merry Wives of Windsor, IV.1.45–49

As with the cabbage (p. 52), Shakespeare is using
the Welsh accent of the parson, Evans, as a punning
device. In this case he is testing the schoolboy William
Page on his Latin.

Gerard began his description of the garden carrot
with the leaves 'of a deepe greene colour, composed
of many fine Fennell-like leaves, very notably cut or
jagged; among which riseth up a stalke straight and
round'. The Anglo-Saxons called the carrot 'bird's
nest', and Gerard, ever observant, noted 'The whole
tuft [of flowers of the wild type] are drawne togither
when the seede is ripe, resembling a birdes nest.'

He talked of the root being 'of a faire yellow colour
pleasant to be eaten, and very sweete in taste'; another
type was of a blackish red colour.[12] Other writers also
mentioned white carrots. The modern orange vegetable
is said to have been bred from this range of colours by
the Dutch as a tribute to the House of Orange.

Gerard explained that they were commonly boiled, yielding little nourishment. The opposing view was held by others in the 1590s, when a series of disastrous corn harvests resulted in a serious dearth: a probable allusion to the destructive storms was made by Shakespeare in *A Midsummer Night's Dream* with the quarrel between Titania and Oberon. A linen draper from Shrewsbury, Richard Gardiner, published a treatise in 1599 providing advice on helping the starving poor, and the carrot was his particular favourite:

> Carrets in necessitie and dearth, are eaten of the poore people, after they be well boyled, instead of bread and meate. Many people will eate Carrets raw, and doe digest well in hungry stomackes: they give good nourishment to all people, and not hurtful to any.[13]

Root vegetables at this time were regarded as being food fit only for the poor and their animals, but sophisticated recipes were beginning to appear in cookery books. Thomas Dawson in *A New Booke of Cookerie* in his *Good Huswifes Jewell* of 1596 advised: 'carret rootes being minced, and then made in the dish after the proportion of a flowerdeluce, then picke shrimps and lay upon it with oyle and vinegare'.[14]

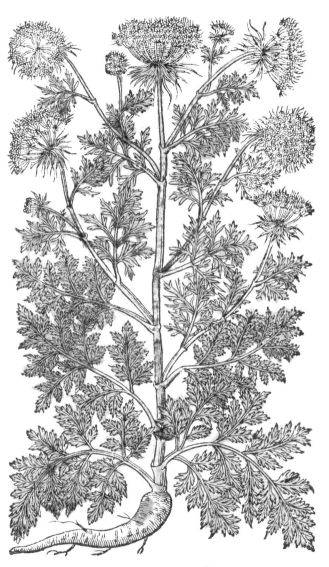

Pastinaca sativa tenuifolia
Yellow Carrot

Cherry

Helena　　　　So we grew together,
Like to a double cherry: seeming parted,
But yet an union in partition,
Two lovely berries moulded on one stem.

A Midsummer Night's Dream, III.2.209–212

Puck, the mischievous sprite, has applied the juice
of love-in-idleness (p. 132) in error to Lysander
rather than the 'disdainful youth' Demetrius, causing
ructions between their lovers, Helena and Hermia.
Helena is here reproaching Hermia, her childhood
friend.

Although it was probably the Romans who intro-
duced the cherry tree to Britain, it fell to Henry VIII
to encourage their cultivation after enjoying the fruit
in Flanders. In one of the first English county histories
to be compiled, *A Perambulation of Kent*, published
in 1577, William Lambarde described how an Irish
gardener, Richard Harris, imported apple grafts from
France, and cherry and pear grafts from the Low
Countries, cultivating them in Teynham on land
given to him by the King. According to Lambarde,
'our honest patriot Richard Harris (fruiterer to King
Henry the 8) planted by his great cost and rare

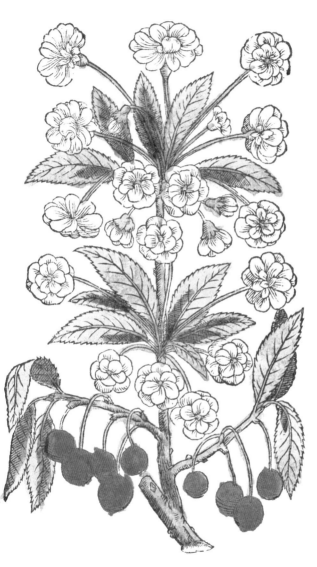

Cerasus multiflora fructus edens
The double flowerd Cherrie tree bearing fruit

industry the sweet cherry, the temperate pippin and the golden rennet'.[15] Here, in what is known as the Garden of England, the cherry flourished in particularly favourable conditions.

Gerard talked of the double flowering cherry, illustrated here, which paradoxically did not produce as many fruit as the single. He planted his in the garden next to a brick wall, describing the smell of the white blossom as like hawthorn. John Parkinson loved the show of the double blossomed so much that he wrote 'I am unwilling to bee without them.'[16]

Gerard, as ever, was suspicious of eating the fruit raw, especially if the cherries were bought in the market during time of plague. Instead, he recommended cooking them in tarts. Elinor Fettiplace had a whole section on the cooking of cherries in her receipt book, including crystallized ones for the banquet course. She also had a recipe for cherry marmalade, which she called 'ruf marmalad', where the fruit was boiled until it became a mass thick enough to cut with a knife.[17]

Columbine

Ophelia There's fennel for you, and columbines.

Hamlet, IV.5.179

This is part of Ophelia's famous speech, when she
gives a list of plants to strew in memory of her dead
father Polonius, stabbed behind the arras (see also
pp. 164 and 167). Fennel was used as a physic herb
for various medical problems. Gerard described how,
powdered, it was added to liquid to help eyesight, or
as a decoction for the kidneys and to void a stone. The
roots could be boiled and put in wine to treat dropsy.

Columbine was the native form of aquilegia, to
be found in hedgerows as well as gardens. It enjoyed
a wide range of alternative names in different parts
of England thanks to the distinctive form of flowers,
described by Gerard as 'five little hollowe hornes, as
it were hanging foorth, with small leaves standing
upright, of the shape of little birds'. The birds in
question were doves, or *columba*. Other names were
connected with clothes – 'granny's bonnet', 'fool's
cap', 'old woman's nightcap' – and footwear: 'boots
and shoes' and 'shoes and stockings'. It was one of the
flowers connected with the Virgin, and also took the

name Our Lady's Shoes, as it was said to spring up where Mary's feet touched the earth on her way to visit her cousin, Elizabeth. In French, the assonance of its name, *ancolie* with *melancholie*, has forged another link to the Virgin and her sorrows. Shakespeare may therefore have chosen to include the columbine in Ophelia's mournful list.

Gerard wrote how 'they are set and sowen in gardens for the beautie and variable colours of the flowers', listing blue, red, purple and white-flowered columbines, and talked of a mixture of colours. He also called them 'Herba Leonis, or the herbe wherein the Lion doths delight'. The seed could be mixed with saffron in wine for stopping of the liver and yellow jaundice, but Gerard made clear that the flowers were particularly used for decoration – in garlands, for example.[18]

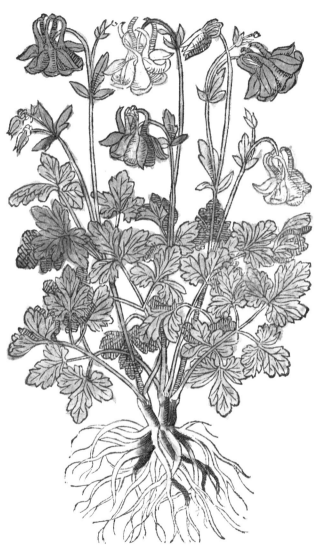

Aquileia rubra
Red Columbines

Crab apple

When roasted crabs hiss in the bowl,
Then nightly sings the staring owl:

Love's Labour's Lost, V.2.909–910

The song that marks the end of *Love's Labour's Lost* is divided into two, beginning with summer, the realm of the cuckoo (see p. 104). Winter opens with the famous line 'When icicles hang by the well', and describes the realm of the owl.

The roasted crabs hissing in the bowl are crab apples, or wildings, as Gerard described them, to distinguish them from 'manured' or cultivated apples. Raw crab apples are inedible, but in the sixteenth century they were roasted in the hot coals of the open fire, then mashed and added to liquor to make a hot drink, lamb's wool, often served in a wassail bowl in midwinter. For the Sussex version, the mashed crabs were added to ale, pressed through a sieve, and sweetened with ginger and nutmeg. It would seem that sometimes the crabs were left whole, for in *A Midsummer Night's Dream* Shakespeare has the sprite Puck boasting of his mischiefs, including lurking 'in a gossip's bowl',

Malus sylvestris rubens
The great Wilding, or red Crab tree

In very likeness of a roasted crab,
And when she drinks, against her lips I bob,
And on her withered dewlap pour the ale.

(II.1.47–50)

The mashing of crab apples was an important autumnal task for gardeners, either using a mill or mashing with wooden mallets into a trough. According to Gerard, the resultant mixture combined with ale could be made into a cold ointment to relieve scabbed legs and scalds, or as an astringent drink to bind looseness of the bowels.

The juice from crabs, verjuice, was also an important element in cookery at a time when lemons were not easily available in country districts. An old Sussex recipe runs:

> Take crabs as soon as the kernels turn black, lay them in a heap to sweat, then pick out the stalks and any rotten that may be in them, force them to a mesh [mash], squeeze them in a hair bag, put the juice into bottles, and stop them for use.

The verjuice then stood for at least a month. It could be added at the last moment to a casserole of, for example, capons or mutton, to give bite to the sauce.[19]

Crown imperial

Perdita Now, my fair'st friend,
I would I had some flowers o'th' spring that might
Become your time of day; ...
 ... bold oxlips, and
The crown imperial;

The Winter's Tale, IV.4.112–114, 125–126

Perdita makes a list of spring flowers to counter the
striped and streaked carnations bred up by florists that
she had just mentioned (see p. 58). Among the native
flowers in her list, such as oxlips and primroses, she
also includes the crown imperial, an exotic introduc-
tion from the Middle East that arrived in Europe
around the year 1580.

The crown imperial was a flamboyant relation of
the snakeshead fritillary, which had been growing in
Europe's meadows for centuries. Gerard likened the
snakeshead to a guinea fowl, calling them 'Ginny hen',
and, noting their pattern, which resembled the table
on which chess or chequers was played, referred to
them as 'checkered daffodils' (see p. 19). So recent was
the arrival of the crown imperial that Gerard did not
know of its relationship to his checkered daffodils.
This is not surprising, as the plant looked quite

different: large and stately with flowers ranging from yellow through orange to red. He described how 'the flowers grow at the top of the stalke, compassing it round about in forme of an Imperiall crowne, (whereof it tooke his name) hanging their heads downwards as it were bels.' Tradition had it that the flowers hung their heads in shame because they stared boldly at Christ on his way to his crucifixion. Despite its elegance, the crown imperial has one drawback: its smell. Gerard was quick to observe this, describing it as very loathsome, 'like a fox'.[20]

Because of its size and striking appearance, the crown imperial was often planted in the centre of round beds, as the crowning feature. John Evelyn, writing instructions for his apprentice gardener in the late seventeenth century, advised him to keep a garden set aside for coronary flowers, for garlands and wreaths, and for flower arrangements where the desired effect was to be crown-like with the most dramatic flowers at the top. The crown imperial would be ideal for such a role.

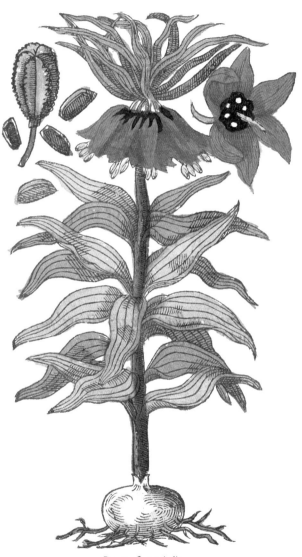

Corona Imperialis
The crowne Imperiall

Daffodil

> *Perdita* daffodils,
> That come before the swallow dares, and take
> The winds of March with beauty;
>
> > *The Winter's Tale*, IV.4.118–120

In her consideration of flowers that are appropriate for different ages of man, Perdita begins with the daffodil, one of the harbingers of spring. One theory about the name is that it is derived from the Old English *affodyle*, meaning 'that which cometh early'. Another is that it comes from asphodel, to which the initial *d* has been added.

In Shakespeare's time, the daffodil grew wild and in profusion in the countryside. As late as the nineteenth century, trains called 'Daffodil Specials' were laid on to transport Londoners down to the West Country to see the swathes of yellow flowers and to buy bunches at farm gates; while thousands of cut flowers travelled in the opposite direction for sale in Covent Garden market. This is the *Narcissus pseudo Narcissus*, which Gerard called the 'Common yellow Daffodilly', bringing forth leaves in February and flowers in April. A decoction of the roots was used by some physicians as a purgative, especially when added

Pseudonarcissus Anglicus & Hispanicus
Common yellow Daffodilly

to aniseed and ginger, 'which will correct the churlish hardnesse of the working'. The distilled water could be used to bathe those afflicted with palsy.

Gerard recorded several different kinds of daffodil, including the 'double white Daffodill of Constantinople'. This had arrived in England in the diplomatic bags from Ottoman Turkey, dispatched by the ambassador to Lord Burghley, 'the right Honorable the Lord Treasurer, among other bulbed flowers'. John Gerard, as Burghley's horticultural supervisor, was able to take some of the roots and plant them in his garden in London, whereupon they 'did bring foorth beautifull flowers, very white and double, with some yellownes mixed in the middle leaves [petals?], pleasant and sweete in smell'.[21] These would seem to have been a form of white narcissus.

Narcissus albus Polyanthos
The double white Daffodill of Constantinople

Daisy

Her lily hand her rosy cheek lies under,
Coz'ning the pillow of a lawful kiss, ...
Without the bed her other fair hand was,
On the green coverlet, whose perfect white
Showed like an April daisy on the grass,
With pearly sweat, resembling dew of night.

The Rape of Lucrece, 386–387, 393–396

Shakespeare evokes a garden in his description of
Lucrece asleep in her bedroom, going on to liken her
eyes to marigolds (p. 117).

The daisy in Britain has traditionally been a
symbol of simplicity and chastity. Its Latin name of
bellis is said to derive from Belides in Roman myth-
ology. Belides was a nymph pursued by Vertumnus,
the god of seasons and gardens. To escape his
attentions, she was transformed into a field of daisies,
under the care of Venus.

Daisies are ubiquitous, growing wild in meadows,
unbidden in lawns, as well as planted in gardens for
ornament. Geoffrey Chaucer, in his prologue to *The
Legend of Good Women*, talked with pleasure of the
daisy or day's eye, whose appearance announced the
arrival of spring, and which opened with the dawn:

Bellis Hortensis multiplex flore albo
The double white Daisie

To hem have I so gret affeccioun,
… whanne comen is the May,
That in my bed ther daweth me no day
That I nam up and walking in the mede
To seen this flour ayein the sonne sprede.[22]

Gerard described a whole range of daisies, including the double white that is illustrated here. They could be used for all kinds of medicinal purposes. For painful joints and gout they might be made into a paste with 'newe butter unsalted' and mallows. The leaves were added to other pot herbs as a clyster against fevers and inflammation of the intestines. The juice of the leaves 'snift up into the nosthrils, purgeth head mightily of foul and filthy slimie humours: and helpeth the Megrim [vertigo, or possibly migraine]'. He even suggested putting the juice in milk to stop small dogs becoming big.[23]

Deadly nightshade

Friar Laurence … this distilling liquor drink thou off,
When presently through all thy veins shall run
A cold and drowsy humour; for no pulse
Shall keep his native progress, but surcease.…
And in this borrowed likeness of shrunk death
Thou shalt continue two-and-forty hours,
And then awake as from a pleasant sleep.

Romeo and Juliet, IV.i.94–97, 104–106

Poisons play a key role in Shakespeare's romantic
tragedy *Romeo and Juliet*. The Friar here gives Juliet a
sleeping draught to prevent her being married off to
Paris. The liquor that he describes has been identified
as a distillation of deadly nightshade, or belladonna.
The distillation proves so effective that Juliet is
declared dead: when news of this reaches Romeo in
exile in Mantua, he acquires wolfsbane, or aconite
(see p. 40). Returning to Verona, he visits the tomb,
kills Paris and, after giving the sleeping Juliet one last
kiss, takes the deadly poison.

Gerard named belladonna 'Sleeping Nightshade'.
His description of the plant is vivid:

round blackish stalks six foote high, whereupon doe
growe great broade leaves of a darke greene colour:

among which doe growe small hollowe flowers bell fashion of an overworne purple colour; in the place whereof come foorth great round berries of the bignesse of the black cherrie, greene at the first, but when they be ripe of colour of black jette or burnished horne, soft and full of purple juice: among which juice lie the seeds like the berries of ivie.

He explained that the consumption of a few berries caused deep sleep, but if more were taken they could 'bring present death'.[24] The name belladonna was derived from the Italian for 'beautiful woman' because it was the custom of women to use the herb for eyedrops to dilate the pupils, and make them appear more seductive.

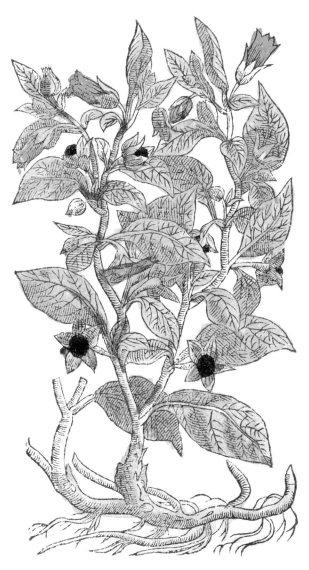

Solanum Læthale
Dwale, or deadly Nightshade

Eglantine

> *Oberon* I know a bank where the wild thyme blows,
> Where oxlips and the nodding violet grows,
> Quite overcanopied with luscious woodbine,
> With sweet musk-roses, and with eglantine.
>
> *A Midsummer Night's Dream*, II.1.249–252

In these famous lines, Shakespeare conjures up the
fragrant bower where Titania, Queen of the Fairies,
sometimes slept, 'Lulled in these flowers with dances
and delight'. The eglantine, sweet briar or *Rosa canina*
is the wild rose that can still be seen scrambling
through British hedgerows. The canine reference
denotes that it is common, as in dog Latin. It differs
from other roses in the arrangement of its sepals.

Along with the wild pansy, the heartsease, the
eglantine rose was particularly associated with
Elizabeth I (see also p. 134). If Shakespeare did indeed
take various aspects of the festivities put on by Robert
Dudley, Earl of Leicester, at Kenilworth Castle in 1577,
and wove them into *A Midsummer Night's Dream*, then
it is not surprising that he introduced the Queen's
favourite rose into the bower of her fairy counterpart.

Elizabeth's choice of the wild rose may have been
influenced by the pride she took in being very much

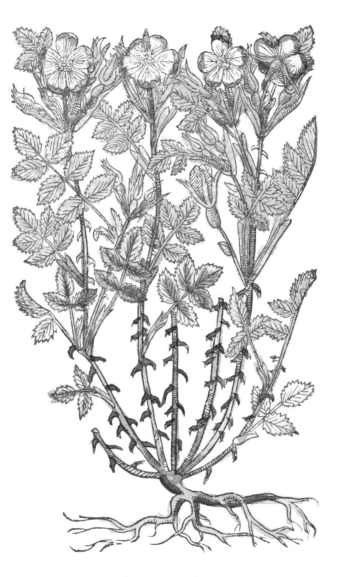

Rosa sylvestris odora
The Eglantine, or sweete Brier

a native of the British Isles. Exceptionally for a royal princess, her mother, Anne Boleyn, was English and a commoner, while her grandmothers were also English-born. When the artist William Rogers produced *Rosa Electa*, a print for sale in the 1590s, he depicted Elizabeth surrounded not only by the Tudor rose, the heraldic hybrid of the Gallica and the alba, but also the eglantine.

Gerard described how the hips of the eglantine and of the musk rose could be cooked in tarts and for banqueting stuff. Children would make them into chains and 'other pretie gew-gawes'.[25]

Fig

Soothsayer You shall outlive the lady whom you serve.
Charmian O, excellent! I love long life better than figs.

Antony and Cleopatra, I.2.27–28

The fig bookends the tragedy of *Antony and Cleopatra*.
Charmian, one of the Queen's attendants, introduces
the fruit in the first act, while Cleopatra ends her life
with the bite of an asp, brought to her in a basket of
figs.

The fig, like the medlar, has long had associations
with female genitalia, as Alan Bates memorably
demonstrated in the film version of D.H. Lawrence's
Women in Love. He not only described how to eat one,
but also reminded his companions how it is the vulgar
word in Italian for the vagina. Shakespeare must have
found this highly appropriate for the story of an exotic
queen famous for her sexual charms.

John Gerard noted:

The fruit commeth out of the branches without any
flower at all that ever I could perceive, which fruite is
in shape like unto Peares, of colour either whitish, or
somewhat red, or of a deepe blewe, full of small grains
within.

This is not only a vivid description, but also observant, for the fig is a botanical peculiarity: neither fruit nor flower, yet partaking of both. It is, in fact, a hollow, fleshy receptacle, enclosing a multitude of flowers that never see the light of day, but come to full perfection and ripen their seed.

In Gerard's garden in Holborn he had a dwarf fig tree that fruited in August. Before the fruit was fully ripe, it produced a white 'milk' that he recommended to use to combat roughness of the skin, including freckles, 'small pockes' or measles.

Once the fruit had come 'to kindly maturitie', its juice was like honey, which Gerard advised 'be good for the throte and lungs' and to ease coughs. 'Stamped', the fruit could be made into a plaster with wheatmeal, fenugreek powder, linseed and marshmallow roots, and applied warm to calm angry swellings. Boiled in wormwood wine (see p. 188) with barley meal, it could be applied to the stomach for those affected by dropsy. He even suggested using the leaves against the King's Evil or scrofula, a tubercular swelling of the lymph glands, as an alternative to being touched by royalty.[26]

Ficus
The Fig tree

Gooseberry

> *Falstaff* … virtue is of so little regard in these coster-
> mongers' times that true valour is turned bearherd;
> pregnancy is made a tapster, and his quick wit wasted
> in giving reckonings; all the other gifts appertinent
> to man, as the malice of this age shapes them, are not
> worth a gooseberry.
>
> *Henry IV, Part 2*, I.2.169–174

In this scene, Sir John encounters the Lord Chief
Justice in a London street, and finds that he has to
defend himself from the charge that he is leading
Prince Hal, heir to the throne, astray.

The gooseberry is a native of the north of England,
and it may be that Shakespeare was making the point
that it was not considered as worthy as more exotic
fruits, just as prophets are often little valued in their
own country. The derivation of the name is a matter
of debate. One theory is that it is a corruption of
crossberry; another is that it took the name 'goose'
because it so often accompanied the serving of a green
(young, unhung) goose at dinner. It was also known
in Shakespeare's time as the feaberry, with *fea* as a
corrupted form of *theve*, Old English for a prickly
shrub.

Vua Crispa
Goose berries

John Gerard noted:

> the fruit is round growing scatteringly upon the branches, greene at the first, but waxing a little yellow through maturity; full of a winie juice, somthing sweete in taste when they be ripe.

He did not think that they provided much nourishment, but with their sharp taste they could be used instead of verjuice (see p. 72) in sauces for meat.[27]

Elinor Fettiplace in her receipt book gave a recipe for cooking chicken with herbs and gooseberries:

> Take a good handfull of parselie, pick it small, & a good handfull of gooseberries, & a pretie quantitie of tyme, mince it small, & three large mace, & put these all together in a dish, & a little pepper, & salt & half a pinte of white wine, & some broth that the chicken were boiled in, & a piece of sweet butter, & let it boile halfe an hower, & when the chickins are boiled inough, put that broth to them, & serve them; put some suger into it.[28]

Hazel

Petruchio Kate like the hazel-twig
Is straight and slender, and as brown in hue
As hazel-nuts, and sweeter than the kernels.
The Taming of the Shrew, II.1.248–250

Petruchio undertakes to woo Katherina to gain her
dowry and to help his friend win her younger sister
Bianca. The comparison with hazel comes when
Petruchio pretends to claim that he has heard that
Katherina is lame. Gerard echoed Shakespeare's char-
acterization of the hazel tree in lyrical terms: 'parted
into boughes without knots, tough and pliable'. He
went on to describe the 'catkins, aglets or blowings,
slender and well compact; after which come the Nuts
standing in a tough cup of a greene colour, and jagged
at the upper end, like almost to the beards in Roses'.[29]
Again like Shakespeare, he talked of the sweetness of
the kernels.

The hazel was the nut of the English hedgerows,
and had its place in the Tudor agricultural year. The
traditional time to go nutting was on Holy Rood Day,
14 September. Six weeks later, on All Hallows Eve, 31
October, came Nutcrack Night when it was traditional
to throw the shells into the fire. Those that burned

brightest would prove to be your love. Hazel nuts might also have been a favoured snack for groundlings watching Shakespeare's plays, for huge amounts of shells were found in the pit when the Rose Theatre was excavated in 1987.

Gerard warned that, despite their sweetness, hazel nuts were not easily digested, either when young and full of moisture, or when old. Too many eaten could result in headaches. But if, like almonds, they were made into a milk, they could bind the stomach, and cool fevers and agues.

The straightness of the boughs made them ideal for making wattle hurdles, along with other pliable branches such as willow, holly, ivy and blackberry. In prehistoric times ancient trackways could be 'paved' with these hurdles, and in later centuries they could be used not only for fencing, but also as the foundation on which wattle-and-daub walls were built, and as broaches to peg down roofing thatch.

Corylus sylvestris
The wilde Hedge Nut

Honeysuckle

Hero ... bid her steal into the pleachèd bower
Where honeysuckles, ripened by the sun,
Forbid the sun to enter ...

Much Ado About Nothing, III.1.7–9

Knowing that Beatrice and Benedick are attracted
to each other, whatever their bickering may suggest,
Hero commands her attendant persuade Beatrice to
go into a garden arbour so that she can overhear what
Benedick truly thinks about her. Pleached arbours
were fashionable features in sixteenth- and early-
seventeenth-century gardens, enabling people to walk
out of the glare of the sun, and often to have a table
for dining alfresco, as shown in contemporary paint-
ings and engravings. The Puritan Philip Stubbes in
his *Anatomy of Abuses*, published in 1583, disapproved of
such private places, complaining 'truly I think [they]
are little better than the Stewes and Brothell Houses
were in tymes past'.[30]

One of the earliest gardening books in English was
The Gardeners Labyrinth. Written by Thomas Hill and
published in London in 1577, it included a woodcut
illustration of gardeners building such an arbour.
Hill explained how 'the herber in the garden may

Periclymenum
Woodbinde or Honisuckles

bee framed with Juniper poles, or the Willowe, either to stretch, or to bound together with Osyers.' He recommended covering this framework with branches of vine, melon or cucumber 'spreading all over… [to] shadowe and keepe both the heate and sunne from the walkers and sitters there under'.[31] Honeysuckle or climbing roses could provide fragrant alternatives.

Gerard listed honeysuckles under woodbines, and provided recipes for the distillation of their flowers and leaves. The flower water could help women with speedy labour in childbirth, while both the flowers and the leaves might ease sore mouths in the young and the old. An alembic or still would be needed for such waters, but no equipment was required to make an ointment to treat a body that had become very cold or 'benumbed'.[32] The flowers would be simply steeped in oil, and then set on a sunny windowsill.

Iris

Perdita Now, my fair'st friend,
I would I had some flowers o'th' spring that might
Become your time of day; …
 … lilies of all kinds,
The flower-de-luce being one!

The Winter's Tale, IV.4.112–114, 126–127

In her list of spring flowers (see also p. 76), Perdita
introduces the flower-de-luce, or iris. In the twelfth
century, Louis VII of France adopted the purple iris
as his symbol. In time the *fleur de Louis* evolved into
the fleur-de-luce and fleur-de-lis, which is often
thought to be the lily, as Shakespeare has it here,
though the term was used to refer to a whole range of
flowers. For example, when the Turkish tulip was first
recorded by a Westerner, the French botanist Pierre
Belon, he talked of *Lils rouges*.

John Gerard was certain of his definition:

There be many kinds of Iris or Flower de luce,
whereof some are tall and great, some little, small and
lowe, some smell exceeding sweete in the roote, some
have not smell at all: some flowers are sweete in smell,
and some without anie: some of one colour, some
of many colours mixed: vertues attributed to some,
others not remembred: some have tuberous or knobbie

roots, others Bulbous or Onion rootes, some have leaves like flags, others like grasse or rushes.[33]

As Gerard also noted, the uses were wide. The 'knobbie rootes' or rhizomes had long served as a purgative and could be used to counter bad breath, while the juice applied externally was said to remove blemishes and freckles. Dried rhizomes from certain varieties, such as the *Iris florentina* illustrated here, were ground to produce a powder, orris, that was scented like violets. Clothworkers and drapers would use orris powder to sweeten their cloths, and house-wives applied it to their linen and laundry. It formed the fixative for potpourri, mixed with spices such as cloves and mace, and the petals of fragrant flowers, such as roses.

The flower was chosen by the Tudor courtier 'Bess of Hardwick' to represent her constancy in the face of tribulation in her fourth marriage, to the Earl of Shrewsbury. A bearded iris rises sword-like and defiant in the plaster frieze of her High Great Chamber at Hardwick Hall in Derbyshire.

Iris Florentina
Flower de-luce of Florence

Lady's smock

When daisies pied and violets blue,
　　And lady-smocks, all silver-white,
And cuckoo-buds of yellow hue
　　Do paint the meadows with delight,

Love's Labour's Lost, V.2.879–882

Shakespeare ends *Love's Labour's Lost* with a song,
contrasting summer, when the cuckoo mocks mar-
ried men with its call, and winter and the hooting
owl (see p. 70). The lovely meadow of native spring
flowers introduces two associated with the cuckoo.
The first, lady's smock, was also known as the cuckoo
flower in various parts of the country. Gerard wrote
charmingly: 'These flower for the most part in Aprill
and Maie, when the Cuckowe doth begin to sing her
pleasant notes without stammering.' He located them
in moist meadows, and in ditches, such as the castle
moat at Clare in Essex.

　　Shakespeare talks in the next verse of maidens
bleaching their summer smocks, which chimes with
his description of the flowers as silver-white. Gerard
also made them white 'overdasht or declining toward
a light carnation', although most modern books of wild
flowers would characterize them as lilac in colour.

Cardamine Trifolia
Three leafed Ladie smocks

Cuckoo bud is an old name for the buttercup. Other names include crowfoot and the butter flower, which was Gerard's principal name for it. He described it as having 'small flowers with five leaves a peece, of a yellow glittering colour like golde', although he did find a double flower while walking to one of the London theatres with his botanist friend, the merchant Nicholas Lete. He warned that the crowfoot was not safe to be taken, requiring 'exquisite moderation' and care from the physician.[34]

Ranunculus pratensis, etiamque Hortensis
Common Crowfoote

Lily

King John has just held his second coronation, which
may have brought him satisfaction, but his nobles feel
that it is a superfluous act, hence Lord Salisbury's
point. The text has become conflated, so that we
now talk of gilding the lily for an unnecessary act or
description.

Only the rose gets more references in Shakespeare's
work than the lily, although it has to be remembered
that 'lily' can be used as a general term for a flower.
The white lily was introduced to Britain from the
Middle East in early times, certainly by the beginning
of the Middle Ages, and was especially dedicated to
the Virgin Mary. Gerard considered that its beauty
and 'braverie excelled Salomon in his greatest roialtie'.
He must also have been familiar with the white lily of
Constantinople through the contacts that his patron,
Sir William Cecil, had with the Ottoman Empire.

But the Madonna lily was not merely an ornament
of the garden; its bulb has traditionally been used to

Lilium album
The white Lillie

mend cuts, and Gerard claimed that 'stamped with honey' it 'gleweth togither sinewes that be cut in sunder'. Cooked in wine and drunk, it was thought to rid patients of the 'poison of pestilence'.[35]

Long purples

Gertrude There is a willow grows aslant a brook
That shows his hoar leaves in the glassy stream.
Therewith fantastic garlands did she make
Of crow-flowers, nettles, daisies and long purples,
That liberal shepherds give a grosser name,
But our cold maids do dead men's fingers call them.

Hamlet, IV.7.138–143

The Queen is here recounting the drowning of
Ophelia, who in her garland had woven flowers native
to English meadows. The name 'crow-flower' has
been applied to the bluebell and a wild form of sweet
william but, given the watery theme, it would seem
that Shakespeare is referring to the marsh marigold.
Long purples are *Orchis mascula*, the early-purple
orchid, or spotted bird's orchis, which has been given
an enormous number of local British names: in his
Englishman's Flora, Geoffrey Grigson lists nearly a
hundred. These include 'bloody butchers', 'goosey
ganders' and 'kecklegs'. Shakespeare's reference to
fingers is reflected in 'bloody-man's [i.e. devil's] fingers'
from Gloucestershire, Worcestershire and Cheshire.

The long purple has two tubers, one slackening as
it empties over the current year, the second new and
firm, ready for next year's growth. This inevitably led

to the idea of testicles or stones, hence Shakespeare's reference to grosser names. In his herbal, Gerard mentioned 'fox-stones', 'dog-stones', 'fool's stones' and 'goat-stones'. He also introduced the satyrion, or satyr's plant. He politely advised that these plants were of 'no great use ... in Physicke, but regarded for the pleasant and beautifull flowers wherewith nature hath seemed to plaie and disport her selfe'.[36]

In fact, the orchid tubers were known as an aphrodisiac in Europe. In their early-seventeenth-century pharmacopaeia, the London College of Physicians provided an electuary for 'a Provocative to Venery', which included orchid tubers and candied eryngo root (see p. 29), along with spices and wine. One botanist wrote in 1664 that enough early-purple orchids grew in Cobham Park in Kent to pleasure all the wives of the seamen in Rochester, while the early American botanist John Josselyn, recorded in 1672 how women in New England collected native orchids 'for an Amorous Cup'.[37] The plant also had religious connotations, for it was believed that it grew under the cross at Christ's crucifixion, so that the flowers were spattered with his blood.

The natural home for the early-purple orchid is non-acidic soils in ancient woodland, hay meadows, chalk downland and limestone pavements. The plant was once very common, but is now much rarer because of the vulnerability of these types of habitat.

Orchis Ornithophora folio maculoso
Spotted Birdes Orchis

Mandrake

Juliet Alack, alack, is it not like that I,
So early waking – what with loathsome smells,
And shrieks like mandrakes torn out of the earth,
That living mortals, hearing them, run mad –

Romeo and Juliet, IV.3.44–47

Juliet is about to take a sleeping draught of belladonna
(p. 83) to feign death and to prevent her marriage to
Paris. She expresses her fear of being placed in the
Capulet family tomb, alongside the body of her kins-
man Tybalt, recently slain, and hearing the shrieks of
mandrakes.

Shakespeare makes several references to mandrakes
in his plays: little wonder, for it is a dramatic plant.
It is related to the potato, but its tubers sometimes
have a resemblance to human form, inspiring all kinds
of stories about its powers, including the idea that it
would scream if uprooted.

Gerard explained in his herbal: 'There have
been many ridiculous tales brought up of this plant,
whether of old wives or some runnagate surgeons
or phisickmongers.' One was that the plant was to
be found growing under gallows, 'where the matter
that hath fallen from the dead bodie, hath given it

Mandragoras mas & fæmina
The male and female Mandrake

the shape of a man; and the matter of a woman, the substaunce of a female plant'.[38] Another tale was that if a man tried to dig it up, he would die soon after, so that a dog should be employed instead.

Gerard was having none of this, pointing out that the roots of carrots, parsnips and other vegetables could also be found in a forked form, like the legs of a man or woman. He and his servants had dug mandrakes up frequently and replanted them with no dire effects. The fruit resembled an apple that could be eaten. Juice from the root in small quantities might purge the stomach, and be put into medicines for pains in the eye. If the root was boiled and infused, it could be made into a sleeping draught, and used as an anaesthetic. Shakespeare was referring to the mandrake or mandragora in this context when he had Iago advise Othello 'Nor all the drowsy syrups of the world / Shall ever medicine thee to that sweet sleep which thou owedst yesterday' (*Othello*, III.3.335–337).

Marigold

Her eyes like marigolds had sheathed their light,
 And canopied in darkness sweetly lay
 Till they might open to adorn the day.

The Rape of Lucrece, 397–399

In his long narrative poem *The Rape of Lucrece* Shakespeare uses garden flowers to describe Lucrece asleep in her bedchamber, beginning with the lily, rose and daisy, and then moving on to the marigold. It was observed that the marigold opened its petals in the morning, and shut them at nightfall, so that in *The Winter's Tale* Shakespeare talks of 'The marigold, that goes to bed wi'th' the sun' (IV.4.105).

The cottager's garden would have been predominantly green, with vegetables and herbs as the principal plants cultivated, so the marigold would provide a brilliant splash of colour. Gerard described the flowers of the double kind as 'beautiful, rounde, verie large, and double, something sweete, with a certain strong smell, of a light saffron colour, or like pure golde'. It was one of the flowers that was associated with the Virgin Mary, hence its name. Alternative names were maybuds, and calendula, from calends, the month, for it was noted that it remained in bloom throughout the

festivals celebrating the Blessed Virgin. Its long period of flowering made it the emblem of constancy.

The petals of the marigold were used in broths and soups, and Gerard thought they could comfort and strengthen the heart. Fresh, or dried, they were used as a cheaper substitute for saffron in cooking. For the months when the flower was not in bloom, grocers and spice sellers would dry the petals and keep them in barrels, to be dispensed 'by the pennie more or lesse'.[39] A manuscript recipe book dating from around 1572, *A Proper Newe Booke of Cokerye*, gave a recipe for a tart made from marigolds. The petals were parboiled until tender, then combined with eggs and cream or curds, and baked in a pastry case. This would be served during the banquet course of a meal.[40]

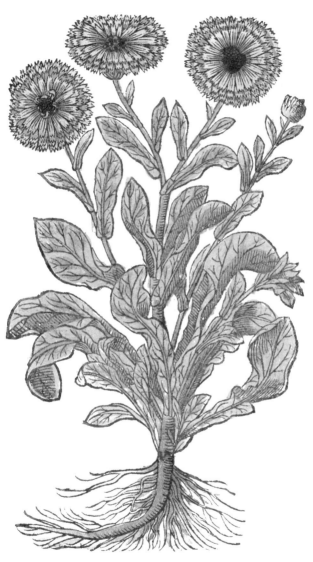

Calendula maior polyanthos
The greater double Marigold

Medlar

Touchstone Truly, the tree yields bad fruit.
Rosalind I'll graft it with you, and then I shall graft
it with a medlar; then it will be the earliest fruit i'th'
country, for you'll be rotten ere you be half-ripe, and
that's the right virtue of the medlar.

As You Like It, III.2.114–118

Rosalind is jesting with Touchstone, the clown,
about some verses that had been pinned to a tree.
Shakespeare clearly was familiar with the distinctive
characteristics of the medlar. A native of northern
Iran, the fruit was introduced to Britain by the
Romans. Its Latin name is *Mespilus germanica*, but the
native Britons called it 'openarse', a description of the
appearance of the fruit. In Tudor England the fruit
was associated with female genitalia, as Shakespeare
noted in a speech made by Mercutio in *Romeo and
Juliet* (p. 138). In France it was dubbed *cul de chien* or
'dog's arse'. Despite these vulgar names and sexual
associations, the medlar is a decoratively shaped tree,
with charming white flowers.

Gerard described how it grew in orchards, but
also in hedges, along with brambles and briars. He
recorded how it was particularly successful if grafted

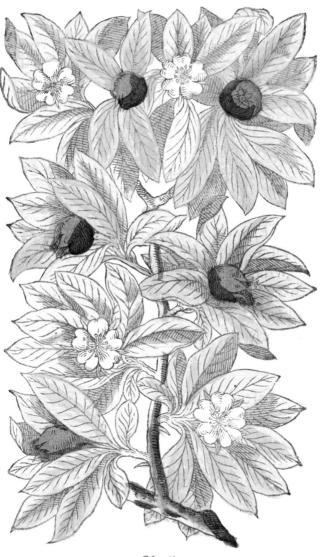

Mespilus
The manured Medlar

on a white thorn, when 'it prospereth woonderfull well, and bringeth foorth fruite twice or thrise bigger then those that are not grafted at all'.[41]

The fruit is picked in October or early November when the fruit is yet unripe, although Gerard recommended eating hard green medlars to 'stop the belly'. Laid in straw, the fruit softens over the following weeks, and can be eaten raw or made into a jelly. Thomas Dawson in his *New Booke of Cookerie*, part of *The Good Huswife's Jewell*, gives a recipe for making a medlar tart to be served in the banqueting course of a meal:

> take medlers that be rotté, and stamp them, then set them on a chafing dish and coales, and beate in two yolkes of egges, boyling it till it be somewhat thick, then season them with suger, cinamon, and ginger, and lay it in a paste.[42]

Mistletoe

Tamora A barren detested vale you see it is;
The trees, though summer, yet forlorn and lean,
Overcome with moss and baleful mistletoe.
Here never shines the sun ...

Titus Andronicus, II.3.93–96

Titus Andronicus is one of Shakespeare's most horrific
plays, with one character having her tongue cut out
and her hands cut off, while children are served up to
their mother cooked in a pie. Tamora, Queen of the
Goths, is here indicating a pit, to which she claims she
has been lured. In keeping with this Gothic horror,
Shakespeare attributes active evil to mistletoe. This is
a theme echoed by Hugh Platt in his *Floraes Paradise*,
published in 1608, where he noted 'the roote whereof
there is a mistel child, whereof many strange things
are conceived'.[43]

Much speculation was expended on just how the
mistletoe was able to grow on trees. Gerard thought
that it grew through vaporous moisture. He explained
how it

> groweth upon Okes, and divers other trees almost
> every where ... is alwaies greene, as well in winter
> as in sommer; the berries be ripe in Autumne, they

remaine all winter thorow, and are foode for divers birdes, as Thrushes, Blackbirdes, and Ring Doves.

He described the plant in lyrical terms:

Viscum or Misseltoe hath many slender branches, spred overthwart one another, & wrapped and interlaced one within another: the barke of which is of a light greene or Popinjay colour: the leaves of this branching excrescence be of a browne colour: the flowers be small and yellowe; which being past, there appeere small clusters of white translucent berries, which are so cleere that a man may see through them.

But then he introduced a baleful element, that these beautiful berries 'are full of clammie or vicious moisture, whereof the best Birdlime is made'.[44]

Birdlime, by tradition the dung deposited by thrushes after eating berries, was used to entrap birds. It was also employed by apothecaries to treat hard swellings, often added to frankincense. Highly poisonous, it could also inflame the tongue, distract the mind and weaken the heart and wits.

The association with frankincense, one of the precious gifts brought to the infant Jesus, may have been a reason why mistletoe became part of the Christmas scene in the eighteenth century, although its sinister character meant it was not allowed to appear along with holly, box and ivy in the seasonal decoration of churches.

Viscum
Misseltoe

Mulberry

Titania Be kind and courteous to this gentleman....
Feed him with apricots and dewberries,
With purple grapes, green figs, and mulberries;

A Midsummer Night's Dream, III.1.156–159

The Queen of the Fairies is instructing her four
attendants to find various delights for Bottom the
Weaver. Apart from the dewberry, they are all exotic
fruits, and in Tudor times could grace the banquet,
the third and richest course of a dinner.

Although Shakespeare does not overtly make
the connection, the mulberry was the subject of the
tragedy of Pyramus and Thisbe that Bottom and his
fellow mechanicals had just been rehearsing in the
forest. Ovid in his *Metamorphoses* described how the
white fruit of the mulberry turned to red from the
blood of Pyramus.

As Gerard explained in his herbal, mulberries
could be either white or red, but the leaves of the
former were the favourite food of the silkworm.
Unfortunately James I did not heed this when in 1607
he wrote to the deputy lieutenants of all the coun-
ties, requiring landowners to buy and plant 10,000
mulberry trees in his drive to establish a silk industry

Morus
The Mulberie tree

in England in emulation of Henri IV's enterprise in France. The mulberry trees were all of the black variety that produced red berries, which suited the English climate, but not the taste of the worms, and the silk industry did not take off.

Gerard recorded how the mulberry was the last of orchard trees to bloom, after cold weather had gone in May, and therefore it was known as the wisest tree. The unripe berries could be used for binding the stomach, and the powder from them for cooking meat. Once the berries ripened in August, they could be made into a confection when added to sugar and made into a syrup, which was not only to be enjoyed at a banquet, but also was good for ulcers and for swellings of the tongue. Unlike other fruit, such as apples and pears, the mulberry moved speedily through the stomach, and thus could be safely eaten after meat.

Oak

Prospero I'll manacle thy neck and feet together.
 … thy food shall be
The fresh-brook mussels, withered roots, and husks
Wherein the acorn cradled.

<div align="right">

The Tempest, I.2.464–467

</div>

Prospero is here threatening Prince Ferdinand, who
has just been shipwrecked on the island. The oak plays
a multiple role in the drama, for the spirit Ariel has
been rescued from the tree, where he had been shut
up by the witch Sycorax, and now obeys Prospero's
orders. The earthy primitive theme is extended when
Sycorax's misshapen son, Caliban, offers to dig with
his long nails to provide 'pig-nuts', the root of St
Anthony's herb, *Conopodium majus* (II.2.167).

John Gerard pointed out how acorns were good
for feeding swine, making their flesh hard and sound.
He echoed Prospero's harsh dictat when he turned
to their consumption by humans: 'Acornes if they be
eaten are hardly concocted, they yeelde no nourish-
ment to mans bodie, but that which is grosse, rawe
and colde.'[45] However, Gerard found good medicinal
qualities, as they provoked urine and were a good
antidote to venom and poisons.

But it was the oak apple that really interested Gerard. If boiled in red wine, it was good for fluxes of the blood, and against excessive moisture and swelling of the jaws and almonds or kernels (tonsils) of the throat. Pregnant women who were having problems in childbirth should sit over a very hot decoction of the oak apple in strong white wine vinegar. For those who wanted to make their hair black, they should made a mixture of oak apple with a little brimstone powder and the rhizomes of irises, and then place it in a sunny place for a month. A wash of oak apples would provide a remedy to treat sunburn, freckles, spots and all blemishes of the face.

Finally, Gerard tells us how the oak apple was used as a kind of augury by Kentishmen. Breaking into the apple, if an ant was found this meant plenty of grain; a white worm foretold murrain, a disease that particularly affected cattle; while a spider meant pestilence.

Quercus vulgaris
The common Oke

Pansy

> *Oberon* Yet marked I where the bolt of Cupid fell.
> It fell upon a little western flower –
> Before, milk-white; now, purple with love's wound –
> And maidens call it love-in-idleness.
>
> *A Midsummer Night's Dream*, II.i.165–168

Love-in-idleness, the wild pansy or heartsease, plays a pivotal role in *A Midsummer Night's Dream*. The King and Queen of the Fairies, Oberon and Titania, have quarrelled over a little changeling boy. Oberon directs the mischievous sprite Puck to seek out the flower, planning to press its juice into the sleeping Titania's eyes so that she will fall in love with what she first sees on awakening. He also tries to use the flower to sort out the quarrels of the young lovers from Athens.

Slightly earlier in the scene, Oberon describes a water pageant, involving a mermaid on a dolphin's back, accompanied by a firework display. These ideas echo the magnificent entertainments put on for Queen Elizabeth I by her favourite, Robert Dudley, at Kenilworth Castle in Warwickshire in the summer of 1575. The displays were open to all, and it was estimated that thousands came each day. Among them, surely, was the eleven-year-old William Shakespeare

Viola tricolor
Hartes ease

from nearby Stratford-upon-Avon, who stored up the memories and introduced them into *A Midsummer Night's Dream* twenty years later. The pansy or heartsease was a favourite flower of the Queen, the great enchantress.

The name 'pansy' was derived from *pensée*, thought or imagination, while 'heartsease' meant tranquillity or peace of mind. John Gerard gave further names to the flower, including *Viola tricolor*, love-in-idleness, call-me-to-you, and three-faces-in-a-hood. He explained how the heartease 'groweth in fieldes in many places, and in gardens also'. In his opinion the garden variety is 'more gallant and beautifull than any of the wilde ones'.

The pansy was used as a remedy for ague, especially in children and babies, 'whose convulsions and fits of falling sicknes it is thought to cure'.[46] Gerard also suggested that the distilled water from the flower be given to patients suffering from the French disease, the pox. It is ironical therefore that Shakespeare chose to give the juice from this flower the power to make men and women fall in love.

Parsley

> *Biondello* I cannot tarry, I knew a wench married in
> an afternoon as she went to the garden for parsley to
> stuff a rabbit ...
>
> *The Taming of the Shrew*, IV.5.25–27

The Taming of the Shrew, often found distasteful by
modern audiences, has the question of marriage at
its heart. Baptista Minola, a rich gentleman of Padua,
has two daughters, Katherina and Bianca. Katherina,
as the elder, should be married first, but her shrewish
character has deterred potential husbands. Baptista
is intent on restricting suitors' access to Bianca until
Katherina is safely married. Biondello, the servant of
one of Bianca's suitors, is here alluding to a possible
course of action, elopement.

According to Gerard, parsley was sown in beds
in gardens, and was not fussy about hot and cold,
as long as it had plenty of moisture. The roots and
seeds could be boiled in ale and drunk as an antidote
against poison, and for clysters to relieve the stone or
torment in the gut.

Parsley was cultivated for cooking with meat,
whether boiled, roasted, fried or stewed. With its
sweet taste, the herb was particularly good with

delicate meats such as chicken or, as here, rabbit. In *A New Booke of Cookerie* Thomas Dawson gives a recipe for stuffing a rabbit. He suggests a base of grated bread and minced sweet suet, to which is added a rich mixture of currants, herbs such as parsley along with pennyroyal, winter savory and sweet marjoram, spinach and beets, cloves, mace and sugar with a little cream and salt, egg yolks and minced dates. 'Then mingle al your stuffe together, and put it into your rabbets bellie, and sowe it up with a thred.'[47]

Apium hortense
Garden Parsley

Pear

Mercutio If love be blind, love cannot hit the mark.
Now will he sit under a medlar tree
And wish his mistress were that kind of fruit
As maids call medlars when they laugh alone.
O Romeo, that she were, O that she were
An open-arse, and thou a popp'rin' pear.

Romeo and Juliet, II.1.33–38

Mercutio is here indulging in sexually explicit language in his discussion with Benvolio in an orchard, knowing that Romeo can overhear them over the wall. The mistress in question is Rosaline, with whom Romeo is in love at the beginning of the play.

The association between the medlar and an arse would have been familiar to Shakespeare's audience (p. 120). In the first printed edition of the play '*et caetera*' was inserted next to the 'O', and it has been suggested that the Lord Chamberlain's censors made this addition. Another possibility is that the playwright added it himself to spare the blushes of the boy actors in the company. John Parkinson described the popp'rin or popperin as a firm, dry pear, somewhat spotted and brownish on the outside, rather like the modern Conference. It was a Flemish pear, probably

Pyrum Palatinum
The Burgomot Peare

named after Poperinge, in the marches of Calais, and therefore easily imported into England until the loss of the port in the reign of Mary Tudor.

Shakespeare's other reference to a specific kind of pear, Warden, is also named after a place: Wardon Abbey, a Cistercian monastery in Berkshire. In *The Winter's Tale*, the Clown refers to adding saffron to warden pies (IV.3.44–45). Raw pears were considered bad for the digestion, and therefore it was recommended that they should be well cooked, usually baked in 'coffins', pastry cases, with sugar, honey and spices. Saffron would have been added for colour, just as in more recent times cochineal has been added to stewed pears, and now more commonly red wine.

John Gerard mentioned neither poperins nor Wardens, but listed a whole series of domestic varieties, such as the bergamot illustrated here, along with wild pears. As there were so many to choose from, he decided to give one general description, for to describe them apart 'were to send an Owle to Athens, or to number those things which are without number'.[48] To overcome the difficulty of digestion, he suggested making pears into perry, to warm the stomach.

Poppy

Iago Not poppy, nor mandragora,
Nor all the drowsy syrups of the world
Shall ever medicine thee to that sweet sleep
Which thou owedst yesterday.

Othello, III.3.334–337

Iago is, in fact, applying poisons of suspicion
rather than opiates to Othello here. Shakespeare's
mandragora is the mandrake (see p. 116). The narcotic
properties of the opium poppy, *Papaver somniferum*,
have been known for thousands of years. According to
one Greek legend, Demeter, the goddess of harvest,
took the fruit of the poppy to console herself when
her daughter Persephone was snatched by Hades. This
poppy made its way to England from Southern Europe
in the Middle Ages, but its popularity as a garden
flower did not come until double-flowered forms were
introduced from Constantinople in the sixteenth
century.

Gerard made a distinction between the black
poppy, which he thought yielded opium, and the
white, which he called the garden poppy, although
there is no botanical difference. He welcomed the
double red flowers for the garden, but was also wary,

calling the poppy 'faire without and fowle within'. 'Our gentlewomen', he recorded, called it Joan Silver Pin. Opium is the gummy latex that oozes out of the green, unripe seed pods when they are slit. Once ripe, the seed loses the alkaloids that make up its potency, and can be used safely in cooking. The potency shocked him, and he warned that it mitigated 'all kindes of paines, but it leaveth behinde it oftentimes a mischiefe woorse than the disease it selfe, and that hard to be cured, as a dead palsie and such like'.[49]

Shakespeare's poet contemporary, Edmund Spenser, also stressed the baleful character of the poppy. In the Garden of Proserpine in *The Faerie Queene*, he wrote of the

> … direfull, deadly blacke both leafe and bloom
> Fit to adorn the dead, and decke the drery toombe.[50]

On a lighter note, Gerard described how poppy seeds could be used in baking and in comfits to be eaten in the banquet course of meals.

Papaver multiflorum coccineus
Scarlet double Poppie

Potato

Falstaff Let the sky rain potatoes, let it thunder to the tune of 'Greensleeves', hail kissing-comfits, and snow eringoes;

The Merry Wives of Windsor, V.5.18–20

This extraordinary speech comes towards the end of the play, when Sir John is looking forward to a romantic assignation with one of the merry wives in Windsor Great Park. Exotic fruits and vegetables were arriving in Tudor England as new worlds were opening up. The Virginia potato (*Solanum tuberosum*) in fact came originally from Peru, brought to Europe by Spanish sailors in the 1530s or 1540s. The name 'potato' was also applied to another quite separate botanical vegetable, the sweet potato or 'skirrets of Peru' (*Ipomea batata*). This was probably brought back to England by John Hawkins from his voyage to the coast of Guinea in 1564.

Aphrodisiac powers were often attributed to these exotic imports: for example, the tomato from Mexico was known as the 'love apple'. Shakespeare goes on to talk of a snowstorm of eryngoes, sea hollies that had also just arrived in England, and may too have been regarded as helpful to the would-be lover (see p. 29).

Battata Virginiana sive Virginianorum & Pappus
Potatoes of Virginia

John Gerard was the first English writer to illustrate potatoes in his herbal. He recorded how he had received roots of the Virginian potato and that they 'growe and prosper in my garden, as in their owne native countrie'. He suggested various ways of cooking both types of potato: by roasting them in the embers, boiling them with prunes, or dressing them with oil and vinegar. He ended his cookery advice by noting, 'notwithstanding howsoever they be dressed, they comfort, nourish and strengthen the bodie, procure bodily lust, and that with greediness'.[51] Music no doubt to Falstaff's ears.

Despite Gerard's commendation, the potato was not adopted with enthusiasm by the English. Many feared not only that divine retribution would be dealt through eating forbidden fruit, but that potatoes carried leprosy, scrofula and fever. Only in the late eighteenth century did it become a significant part of the nation's diet. Meanwhile in Ireland the vegetable had early been a vital staple for the poor, with tragic consequences when the crops were hit by blight.

Primrose

Perdita pale prime-roses,
That die unmarried ere they can behold
Bright Phoebus in his strength – a malady
Most incident to maids;

The Winter's Tale, IV.4.122–125

Perdita gives her catalogue of flowers appropriate to
the ages of man at an annual feast in summer (see also
pp. 60, 73, 76, 101). Here she laments the lack of spring
flowers to offer to Florizel (disguised as a young
countryman) and the Shepherdess.

Primroses, along with violets (p. 182), were
particularly associated with the death of the young.
Shakespeare talks of the paleness of primroses, evok-
ing the anaemic appearance of girls suffering from
'green sickness'. This was a condition known as hypo-
chromic anaemia, thought to be due to iron deficien-
cy. Shakespeare actually mentions green sickness in
Pericles, and must have been aware of the theory of the
sixteenth-century German physician Johannes Lange
that it was a disease peculiar to virgins, who if they
were to marry and conceive a child would recover.

Gerard took a rather different medical line. The
roots of primroses, or paigles as they were often

known, if stamped and strained, could be sniffed into the nose to purge the brain and to calm migraine. He also quoted a London apothecary, famous for curing the frenzy by giving patients a diet of the leaves and flowers of primroses, boiled in water, rosewater and betony, with the addition of sugar, pepper, salt and butter.

Shakespeare also makes a very different allusion to the flower when he refers to the primrose path as a life of ease and pleasure, with hints of sinfulness. In *Hamlet*, when Laertes advises his sister Ophelia that she should resist any advances from the prince, her response is to warn him of double standards: 'like a puffed and reckless libertine / Himself the primrose path of dalliance treads / And recks not his own rede' (I.3.49–51). The idea is echoed in *Macbeth* when the porter talks of going 'the primrose way to th'everlasting bonfire' (II.3.18). Why the primrose is chosen for this role is not known.

Primula veris minor
Fielde Primrose

Pumpkin

Mistress Ford We'll use this unwholesome humidity, this gross watery pumpkin. We'll teach him to know turtles from jays.

The Merry Wives of Windsor, III.3.37–38

The merry wives are planning to teach Sir John Falstaff a lesson by putting him in a laundry basket, carrying him to the whitsters of Datchet Mead and emptying him into the muddy ditch. How brilliant of Shakespeare to compare the overweight, outrageous knight to a pumpion, or pumpkin! Not only is the physical image conjured up, but also the loutishness of his behaviour, for in Greek 'pompion' also meant a weak and soft-headed person, and in English we use the term 'bumpkin'.

'Pumpion', 'pompion', 'pumpkin' are general terms for the family *Cucurbitaceae*, which also includes melons, gourds, cucumbers and marrows. These are all recorded by Gerard, some with wonderful names such as 'the great long Pompion', 'the great round Pompion' and 'the great flat bottom'd Pompion'. He explained that 'all these Melons or Pompions bee garden plants: they joy best in a fruitfull soile, and are common in England.' To make their soil more

Pepomaximus compressus
The great flat bottom'd Pompion

fruitful, horse dung might be applied, in a kind of hot bed. The garden writer Thomas Hill described in *The Gardeners Labyrinth* how their climbing habit made them ideal for arbours (see p. 100).

Gerard noted that the pulp of pumpkins was never eaten raw, but boiled, and warned 'when it is not well digested … it maketh a man apt and readie to fall into the disease called the Cholerike passion, and of some the Felonie.'

Cucumbers, he felt, should be cut up and cooked in oatmeal to make a kind of ointment for the cure of 'copper faces, red and shining firie noses (as red as red Roses) and pimples, pumples, rubies and such-like precious faces'.[52] Falstaff clearly got his comeuppance with Alice Ford's analogy.

Quince

Lady Capulet Hold, take these keys, and fetch more
 spices, Nurse.
Nurse They call for dates and quinces in the pastry.

Romeo and Juliet, IV.4.1–2

The Capulet household is preparing the banquet to
celebrate the marriage of Juliet to Paris. A pie of dates
and quinces would be an exotic dish appropriate for
a special occasion, but quinces also had a particular
connection with weddings. According to Plutarch, a
decree handed down by Solon in Athens stipulated
that a bride should eat a quince before lying with
her husband, for it brought fertility. The tradition
continued right through to the Renaissance, as shown
in sixteenth-century paintings.

The quince could not be eaten raw, so would be
cooked in a pie. In *A New Booke of Cookerie* by Thomas
Dawson in his *Good Huswifes Jewell* he gave the
following recipe:

> To bake quince pies. Pare them and take out all
> the Core: then perboyle them in water till they bee
> tender: then take them foorth; and let the water
> runne from them till they be drie. Then put into
> everie Quince, Sugar, sinamon and ginger, and fill

everie pie therewith, and then you may let them bake the space of an houre, and so serve them.[53]

Rather than adding dates, he recommended hard apples or Warden pears.

Another way of cooking quinces was to make them into a kind of marmalade, or 'Cotinate', as Gerard calls it. Dawson provided a recipe for preserving quinces that would keep for a year. He suggested adding sugar and water to pared and cored quinces, letting them boil over a 'soft fire, and when they be skimmed cover them close that no ayre maye come out from them, you must put cloves and sinamon to it after it be skimmed, of quantitie as you will have them to taste'. The cook would know when they had boiled enough by hanging a linen cloth between the cover and the pan with part of it hanging in the liquid, and 'when the cloth is very red they be boiled enough, let them stand till they be colde'.[54]

Gerard echoed the belief that quinces were good to be fed to brides by quoting the theory that 'the woman with childe, which eateth many Quinces during the time of hir breeding, shall bring foorth wise children, and of good understanding.'[55]

Malus Cotonea
The Quince tree

Rhubarb

Macbeth What rhubarb, cyme, or what purgative drug
Would scour these English hence?

Macbeth, V.3.57

Macbeth has just received news of his wife's madness
and death. When he asks how rooted sorrow can be
eradicated, the physician advises 'therein the patient
must minister to himself'. Defiantly the King responds
'throw physic to the dogs; I'll none of it', asking what
is the use of taking the well-known purgatives of the
sixteenth century as he prepares to do battle with the
English army gathered by Malcolm and Macduff.

Some think that 'cyme' was the First Folio com-
positor's misreading of 'cynne', a spelling variant of
'senna'. Only with the publication of the Fourth Folio
in 1685 did 'senna' make its appearance.

The Mediterranean plant hardly grows in Britain,
but its pods were known to Gerard, who described
it as a 'singular purging medicine in many diseases,
fit for all ages and kindes'. It was often mixed with
rhubarb.

Gerard recorded different kinds of rhubarb, but
noted that the best came from China, 'fresh and
newe, of a light purplish red, with certain vaines and

Rha Capitatum L'Obelii
Turkie Rubarbe

braunches'. It was brought westwards along the Silk Road, together with other precious commodities. An early-fifteenth-century report to Timur, the great Turko-Mongol ruler, noted how the best merchandise coming to Samarkand from China included rhubarb along with luxury textiles, musk and precious gems. The cost of transportation was immense, so that rhubarb was estimated many times more valuable than expensive ingredients such as opium and saffron. In his herbal Gerard included an illustration of a dried stem. For a living plant, he reproduced Turkish rhubarb as illustrated here. This was probably the kind that Shakespeare knew.

The purgative qualities are listed 'for those that are sicke of sharpe and tertian fevers'. So effective did physicians find it, that rhurbarb was known as 'the life of the liver'.[56] Elinor Fettiplace made her own rhubarb pills, noting philosophically that 'if it never work it can not hurt'.

Sena Orientalis
Sene of the East

Rose

> *Plantagenet* Let him that is a true-born gentleman ...
> From off this brier pluck a white rose with me.
> *Somerset* Let him that is no coward nor no flatterer ...
> Pluck a red rose from off this thorn with me.
>
> *Henry VI, Part 1*, II.4.27–30

This declaration of faction, which developed into war, is set by Shakespeare in the Temple Garden in London around the year 1455. Plantagenet is Richard, the heir to the dukedom of York; Somerset is John Beaufort, who became leader of the Lancastrian faction that supported Henry VI, a weak king prone to lapse into a catatonic state. The scene was almost certainly a figment of Shakespeare's imagination, while the name, Wars of the Roses, that was attached to the ensuing civil war was probably first coined by Sir Walter Scott in his novel *Anne of Gerstein*, published in 1829, where he referred to 'the civil discords so dreadfully prosecuted in the wars of the White and Red Roses'.

The white rose of York, also probably a later invention, was described by Gerard as *Rosa alba* with 'very long stalkes of a woodie substance, set or armed with divers sharpe prickles'. The red rose of

Rosa alba
The White Rose

Lancaster, *Rosa rubra*, 'groweth very lowe in respect of the former [white]: the stalkes are shorter, smoother and browner of colour'. The rose has more references in Shakespeare than any other plant, and Gerard likewise gave the longest account of its virtues, reminding the reader 'it is the honor and ornament of our English Scepter, as by the coniunction appeereth in the uniting of those two most royall houses of Lancaster and Yorke'.

The uses of the rose in cooking, medicine and providing fragrance for the house were also manifold. One exotic use was for sugar paste, a kind of uncooked fondant, but Gerard avoided the issue by calling this 'impertinent unto our historie, bicause I intend neither to make thereof an Apothecaries shop, nor a Sugar bakers storehouse, leaving the rest to our cunning confectioners'.[57] Sir Hugh Platt, in *Floraes Paradise*, described how a complete dinner service might be made out of sugar plate, and that the guests could go out into the garden and pick flowers that had been candied as they grew, 'so you may bid your friends after dinner to a growing banquet'.[58]

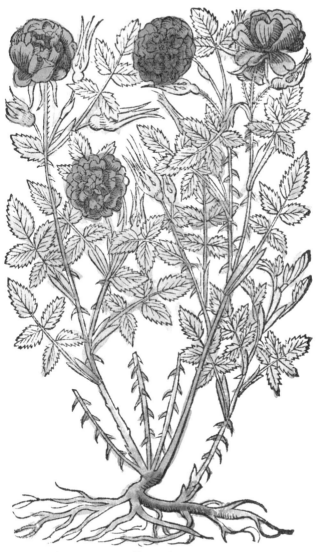

Rosa rubra
The Red Rose

Rosemary

Ophelia There's rosemary, that's for remembrance.
Pray, love, remember.

Hamlet, IV.5.175–176

So begins the list of herbs and flowers spoken by
Ophelia in her distraught state (see also pp. 67, 167).
Rosemary originated from the Mediterranean, though
adapts well to colder climates. Its name is derived
from the Latin, *ros* for 'dew' and *marinus* 'of the sea'.
But it is also associated with the Virgin Mary. One
tradition is that she hung her linen to dry on the bush,
giving the herb its distinctive fragrance. Another
is that she spread her blue cloak over a bush, thus
turning the white flowers into blue.

Gerard picked up on the theme of remembrance in
his description of the plant's virtues:

> Rosemarie is given against all fluxes of bloud; it is also
> good especially the flowers thereof for all infirmities
> of the head and brain, proceeding of a colde and moist
> cause; for they drie the braine, quicken the sences and
> memory.[59]

He described how in England and Italy rosemary
was grown into hedges in gardens, and could be kept
overwintered in pots by stoves and in cellars. The

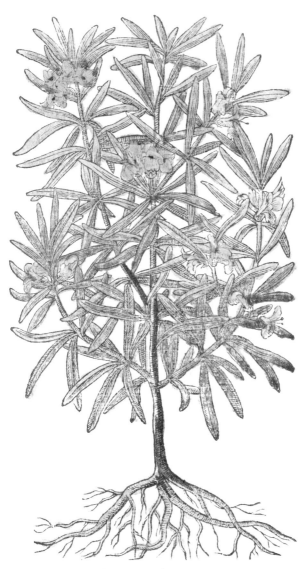

Rosmarinum Coronarium
Garden Rosemarie

little blue flowers could be made into a conserve or candied.

Shakespeare may also be reminding his audience that rosemary was associated with weddings, and that Ophelia had expected to be married to Hamlet. A painting by the Dutch artist Joris Hoefnagel of a Tudor wedding feast at Bermondsey in south-east London, now hangs in Hatfield House in Hertfordshire. The leader of the procession from the church carries a vase with an arrangement of rosemary branches adorned with clove pinks – another plant associated with marriage – and white ribbons.

Rue

Ophelia There's rue for you, and here's some for me.
We may call it herb-grace o' Sundays. O, you must
wear your rue with a difference.

Hamlet, IV.5.179–182

The very name 'rue' conjures up grief and sorrow, so
little wonder that Shakespeare included it in the list of
herbs and flowers composed by the mourning Ophelia.
Its alternative name, 'herb of grace', referred to its used
in exorcisms: a bunch would be added to holy water.

Gerard described how the blue-green herb 'hath
a very strong and ranke smell, and a biting taste',
enjoying sunny and open spaces, and prospering in
rough and bricky ground.[60] He gave a long list of
its medicinal properties, from treating shingles to
running ulcers, earache to nose bleeds. It served as
a counterpoint to deadly poisons such as wolfsbane
(aconite) and toadstools, the bite of snakes, the sting of
hornets, scorpions and spiders. With brave optimism,
he recommended mashing the leaves with the kernel
of walnuts and figs as an antidote to the plague. From
classical times, rue was known as an abortifacient,
and its name comes from the Greek, *ruta*, to set free.
Gerard described how it could expel a dead child.

If handled, rue can bring out severe blisters, and Gerard sensibly warned readers of his herbal to wash their hands after handling the leaves. Nevertheless, it can be used in cooking, with the bitter leaf added to eggs, cheese and fish, or mixed with plums to produce a meat sauce. Rue was one of the ingredients used in a fortified wine called sack.

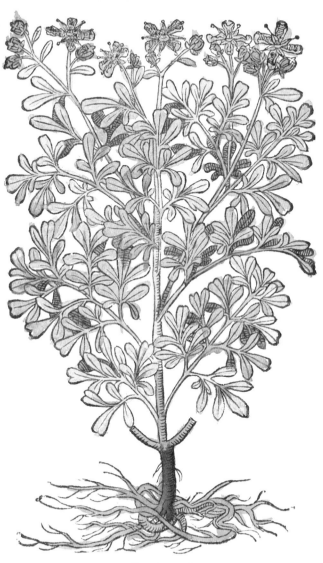

Ruta hortensis
Garden Rue

Saffron

Lafeu No, no, no, your son was misled with a
snipped-taffeta fellow there, whose villainous saffron
would have made all the unbaked and doughy youth
of a nation in his colour.

All's Well That Ends Well, IV.5.1–4

The courtier Lafeu is reassuring the Countess of
Roussillon that her daughter-in-law Helena is
alive, and that her son had been misled by his
companion Paroles. He proceeds to vilify Paroles,
accusing him of show rather than substance, with his
saffron-dyed taffeta slashed to show another colour
beneath.

The yellow dye saffron comes from the *Crocus
sativa*. In the sixteenth and seventeenth centuries
it was cultivated in open fields in Cambridgeshire
and Essex, and gave its name to the town of Saffron
Walden. Harvesting was difficult, requiring skilled
pickers, usually women or girls, who could use their
nimble fingers to extract the tiny stamens. The Tudor
chronicler William Harrison in 1577 described the
process whereby the flowers were gathered 'in the
morning before the rising of the sun, which would
otherwise cause them to welk or flitter [dry up or

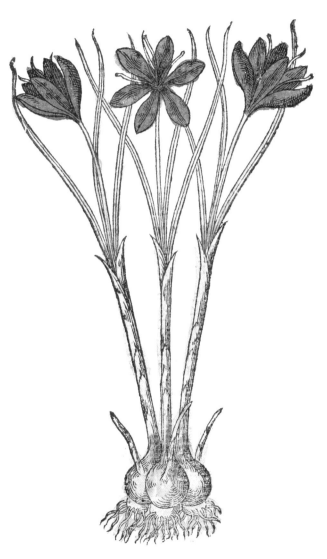

Crocus florens
Saffron in the flower

wither]'.[61] Then they were dried in little kilns and pressed into cakes.

Gerard called all varieties of crocus 'saffron', including the autumn type, which rose 'out of the ground nakedly in September'. The yellow garden crocus he described as having 'flowers of a most perfect shining yellow colour, seeming a far off to be a hot glowing cole of fire'. He recorded how the true saffron crocus grew as plentifully as corn in the fields. The stamens, which he called 'chives', could be steeped in water, and 'serveth to illumine, or as we say, limme pictures and imagerie, as also to colour sundry meates and confections'.[62] Saffron was indeed used as a cheaper alternative to gold leaf, and in Jacobean times the elaborate lace ruffs then fashionable were often dyed with saffron.

In *The Winter's Tale*, Shakespeare has the Clown recommending 'saffron to colour warden pies' (see p. 140). The spice was used to colour the stewed pears, but it could also be employed to colour the casing, just as egg yolk is brushed on pastry today. This would seem to be the context here, with the reference to unbaked and doughy youths. Saffron has fallen out of common use in baking, but the Cornish continue the tradition with their saffron cakes.

Samphire

The blind Earl of Gloucester, in the care of his son
Edgar disguised as a homeless beggar, has arrived in
the countryside near Dover. Gloucester is contem-
plating committing suicide as an escape from the
pain, both physical and mental, with the loss of his
eyes. Determined to prevent this, Edgar convinces
him that they are standing on the clifftop overlooking
the English Channel, so that if he does jump he will
not leap to his death. He evokes the seabirds wheeling
overhead, the fishermen walking along the beach, and
the gatherers of the plant rock samphire.

The English word 'samphire' is derived from the
Italian *herba di San Pietro*, for the Apostle was closely
associated with rocks. In the sixteenth century it was
considered a culinary delicacy, so it was worth the
physical danger and discomfort endured by the collec-
tors, who were suspended on ropes down the cliff face.

Gerard called it 'Rock Sampier', describing how it
'hath many fat and thicke leaves, somewhat like those

of the lesser Purslane, of a spicie taste with a certaine saltnesse'. Among the habitats that he described were the cliffs of Dover. The gatherers would harvest the plant in May and June, ready to be pickled at the beginning of August.

> The leaves kept in pickle and eaten in sallads with oile and vineger, is a pleasant sauce for meate, wholesome for the stoppings of the liver, milt [spleen], kidneies, and bladder; it provoketh urine gently; it openeth the stoppings of the intrals, and stirreth up the appetite to meate.[63]

Gerard also talked of glass- and salt-worts that were to be found in flat marshland. Samphire has recently enjoyed a gastronomic comeback, and may now be purchased from fishmongers, usually as an accompaniment to fish dishes. But, in a hark back to Gerard's description of a sauce for meat, it can be used along with glass- and salt-worts, in a sauce for lamb raised on marshland (marsh lamb).

Crithmum marinum
Rocke Sampier

Strawberry

Gloucester My Lord of Ely, when I was last in Holborn,
I saw good strawberries in your garden there.
Richard III, III.4.31–32

The Duke of Gloucester, intending to arrest Lord
Hastings, wants to get John Morton, Bishop of Ely, out
of the Council meeting by asking for fruit from his
garden. The London garden of the bishop lay just to the
north-west of the City, and maps from the sixteenth
century show how it was surrounded by open fields.

Morton probably sent his servants for *Fragaria
vesca*, or wild strawberries. These were trans-
planted from woodlands into gardens in September or
February, for there were no qualms about uprooting
wild plants at this time. In his *Five Hundred Pointes
of Good Husbandrie* published in 1573, Thomas Tusser
began his advice to women gardeners:

> Wife unto thy garden and set me a plot
> With strawberry rootes, of the best to be got;
> Such growing abroad, among thornes in the wood
> Wel chosen and picked prove excellent good.[64]

The accounts of the royal household of Henry VIII
record that when the gardener carried out planting of
the Privy Garden at Hampton Court Palace, women

Fragaria & Fraga
Red Strawberries

were paid to supply him with strawberry roots from the wild at 3*d* or 4*d* the bushel. Once set in the garden, the strawberries would be cultivated in the same way as we grow our modern, plump fruit that are generally descended from North American plants.

Not far from Ely Place, John Gerard had his own garden. He described how strawberries could be picked for the table, but also how useful their leaves were for medicinal purposes:

> the leaves, boiled & applied in maner of a pultis, taketh away the burning heate in wounds: the decoction thereof strengthneth the gums, fastneth the teeth, and is good to be helde in the mouth both against the inflammation or burning heate thereof.[65]

Elinor Fettiplace made what she called strawberry cakes by cooking the fruit with sugar, pouring it on a pie plate, and when it was dry on one side, cutting it and turning it to dry on the other.

Sweet marjoram

Lafeu 'Twas a good lady, 'twas a good lady. We may
 pick a thousand salads ere we light on such
 another herb.
Clown Indeed, sir, she was the sweet-marjoram of the
 salad, or rather the herb of grace.
Lafeu They are not grass, you knave, they are nose-
 herbs.

All's Well That Ends Well, IV.5.13–19

The courtier Lafeu is here talking to Lavache, the
Countess's clown, about the (supposed) death of the
Countess's daughter-in-law, Helena. The Countess has
set the context by referring to 'rooted love'.

Sweet marjoram, a native of the Mediterranean,
can be cultivated in English gardens as a half-hardy
annual if protected over winter. Its strong perfume
makes it a good candidate for inclusion in the nosegay
– literally an ornament for the nose. In the sixteenth
century, nosegays were carried by public officials,
such as judges and magistrates, to mask the smells of
unwashed crowds and bad sanitation. Marjoram also
has anaesthetic properties, while it was believed that
the herb of grace, rue, could afford some protection
from the plague (see p. 167).

Shakespeare here makes a distinction between herbs for nosegays, and for salads, though the two categories often overlapped. The earliest English recipe for salad that has survived comes from a manuscript, *The Forme of Cury*, compiled by the cooks of Richard II at the end of the fourteenth century:

> Take persel [parsley], sawge, grene garlec, chibolles [spring onions], oynouns, leek, borage, myntes, porrettes [a type of leek], fenel, and toun cressis, rew, rosemarye, purslayne.

The list contains vegetables as well as herbs, and in Elizabethan times flowers such as violets, daisies and primroses would also be included when in season to add colour. The medieval recipe goes on to instruct the cook to mingle the ingredients with 'raw oile; lay on vynegard and salt, and serve it forth'.[66]

John Gerard described sweet marjoram as

> a lowe and shrubbie plant, of a whitish colour and marvellous sweete smell, a foote or somewhat more high.... The flowers grow at the top in scalie or chaffie [wheat-like] spiked eares of a white colour.

He recommended it as an ingredient of 'odiferous ointments, waters, powders, broths and meates', while an extraction of oil could be used in the treatment of cramps and aches.[67]

Maiorana maior
Great Sweete Marirome

Violet

Marina The purple violets and marigolds
Shall as a carpet hang upon thy tomb
While summer days doth last.

Pericles, 15.67–69

Marina, the daughter of Pericles and Thaisa, is taking
a basket of flowers to adorn the tomb of her mother,
whom she believes died at her birth. Shakespeare is
here associating violets with death, especially of the
young, departed before the full beauty of summer. In
Hamlet, Laertes makes a similar reference, when he
wishes violets to spring from the grave of his sister,
Ophelia (V.1.34–35).

On other occasions, Shakespeare emphasizes the
beauty and fragrance of the violet. This was echoed
by Gerard. He talked of how violets 'have a great
prerogative above others, not onely bicause the
minde conceiveth a certaine pleasure and recreation
by smelling and handling of these most odoriferous
flowers but also for that very many by these Violets
receive ornament and comely grace'. He went on to
describe how they were made into garlands for the
head, and into nosegays and posies 'which are delight-
ful to looke on and pleasant to smell to'.

Viola nigra sive purpurea
The purple garden Violet

But the violet was useful as well as beautiful. Gerard described how, made into a syrup, it was good for all inflammations, taking away hoarseness in the chest, and 'ruggedness of the windepipe and jawes'.[68] Elinor, Lady Fettiplace, recorded in her receipt book that she gathered the flowers from her garden at Appleton Manor in Berkshire. Her syrup was very labour intensive, requiring between 4 and 6 pints of petals.

> First mke a thicke syrup of suger and clarifie yt well, then take the blew violetts and picke them well from the whights [base of petals] then put them into the sirrop, let them lie in yt 24 howres keeping yt warme in the meane time, then straine these violetts out and put in fresh, so do 4 times then set them on the fire, let them simper a good while but not boyle fast, put in some Juice of limons in the boyleing, then straine yt and keepe it to yor use.[69]

Violets could also be used in salads. In Thomas Dawson's *A New Booke of Cookerie* in his *Good Huswifes Jewell*, he recommended serving them with 'Salmon cut long waies with slices of onions laid upon it'.[70] The flowers would then be used as a garnish, with oil and vinegar.

Walnut

Ford has flown into a jealous rage, suspecting that his
wife, Alice, has hidden a lover in her laundry basket.
Shakespeare also uses the analogy of the smallness
of a walnut shell elsewhere in his plays. Thus in *The
Taming of the Shrew* Petruchio spurns the offer of a
new cap, comparing it to a 'cockle or a walnut-shell, /
A knack, a toy, a trick, a baby's cap' (IV.3.66–67).

The walnut is a native of Persia and China, and its
foreign origin is reflected in the name 'wal'. Henry
Lyte, for instance, called it the Walshe Nut Tree,
where Welsh was used generally by the English for a
foreigner not of the Teutonic race.

Gerard introduced it as 'a great tree with a thicke
and tall body'. He was an enthusiast of what we call
'wet walnuts', greatly preferring them to the nuts that
had dried out. He described the kernel as

covered with a thin skin, parted almost into fower
parts, with a woodie skin as it were; the inner pulp
whereof is white, sweete and pleasant to the taste, and

that is when it is new gathered, for after it is drie it becommeth oily and ranke.

He continued his preference when discussing the digestive powers: 'fresh nuts slowly descend' when eaten, but dried are hurtful to the stomach, increasing choler, causing headaches and bad for those with coughs. The green, or fresh nuts could be boiled in sugar to make a succade, a kind of sweet usually eaten during the banquet course, here to settle the stomach. The oil derived from the young nuts could be used to make the hands and face smooth, 'taketh away scales and scurffe, blacke and blew marks that come of stripes or bruses'.

However, the dried nuts were added to figs and a little of the herb rue in an ancient remedy attributed to Mithrades, King of Pontus. This 'withstandeth poison, preventeth and preserveth the body from the infection of the plague, and being plentifully eaten they drive wormes foorth of the belly'.[71]

Nux Iuglans
The Walnut tree

Wormwood

Thy sugared tongue to bitter wormwood taste.

Rape of Lucrece, 893

Before taking her own life, Lucrece informs her father and husband of how she has been raped by Sextus, son of Tarquin, King of Rome, and beseeches them to avenge the deed. Wormwood is a member of the Artemisia family, known for intense bitterness, so appropriate in this context.

John Gerard described wormwood as having 'leaves of a grayish colour, very much cut or jagged'.[72] He recommended it for calming the stomach of those troubled with choler, as an antidote against the consumption of harmful mushrooms and toadstools if drunk in vinegar, and against mistletoe and hemlock if steeped in wine. Its name indicates another medicinal purpose, to cure worms, and it has long been used in the preparation of various aperitifs and wines, such as vermouth. So bitter is the taste that in the sixteenth century a distillation would be rubbed on the nipples of a nursing mother to wean the child from the breast, as mentioned by the Nurse in *Romeo and Juliet*.

Absinthium latifolium sive ponticum
Broad leafed Wormwood

The Elizabethan housewife would have found wormwood useful against fleas. Thomas Tusser's verses for July in his *Five Hundred Pointes of Good Husbandrie* included this:

> While Wormwood hath seed, get a bundle or twain
> To save against March, to make flea to refrain:
> Where chamber is sweeped, and wormwood is strown,
> No flea, for his life, dare abide to be known.
> What savour is better, if physic be true
> For places infected than Wormwood or Rue?[73]

Wormwood also kept garments free from moths, like its close relation southernwood, known by the French as *garde-robe*. In England southernwood was commonly called 'lad's love': included in a nosegay for a girl, it indicated fidelity. Another name for it was more sinister: 'Maiden's ruin', and it was said to procure an abortion if made into an infusion, as reflected by its Latin name, *Artemisia abrotanum*. Another relation was mugwort, also known as St John's herb. Picked and purified in the smoke of midsummer bonfires on St John's Eve, 24 June, the herb was made into garlands to hang over the door to keep out the powers of evil, although Gerard dismissed this custom as 'tending to witchcraft and sorcerie'.[74]

Chronology

This is not a full list of Shakespeare's works, but rather of the plays and long poems featured in the plant entries. It is based on the chronology provided by *The Oxford Shakespeare: A Textual Companion*, published in 1987.

Notes

INTRODUCTION

1. John Strype, *The Life of the learned Sir Thomas Smith, Knight*, London, 1698, p. 218.

2. John Gerard, *The Herball or Generall Historie of Plantes*, London, 1597, p. 782.

3. Ovid, *Metamorphoses*, trans. Arthur Golding, Penguin, London, 2002, Book X, p. 319.

4. Gerard, *The Herball*, p. 122.

5. Bendor Grosvenor, *Art History News*, 27 May 2015.

6. Mark Griffiths, 'I know who the fourth man is – it's Shakespeare', *Country Life*, 20 May 2015; 'A Country Controversy', *Country Life*, 27 May 2015.

7. John Barnard, 'Politics, Profits and Idealism: John Norton, the Stationers' Company, and Sir Thomas Bodley', *Bodleian Library Record* 17, 2002, p. 401.

8. Thomas Tusser, *Five Hundred Pointes of Good Husbandrie*, p. 229, edition of 1580 collated with 1573 and 1577, plus the 1557 (unique copy) of *A Hundreth Good Pointes of Husbandrie*, ed. with notes and glossary by W. Payne and S.J. Herrtage for the English Dialect Society, London, 1878.

9. E.F. Benson, *Queen Lucia*, Corgi, London, 1979, p. 12.

10. Esther Singleton, *The Shakespeare Garden*, Century, New York, 1922, pp. viii–ix.

11. British Library, Add.MS 3983. For a transcript, see Andrew Eburne and Katz Fetuś, eds, *Lyveden New Bield Conservation Management Plan*, National Trust, 2008, p. 208.

THE PLANTS

1. John Gerard, *The Herball or Generall Historie of Plantes*, London, 1597, pp. 823–4.
2. Ibid, pp. 301–5.
3. John Parkinson, *Paradisi in Sole*, London, 1629, p. 587.
4. Sir Thomas Elyot's *Castel of Helth*, London, 1541, quoted in Sara Paston-Williams, *The Art of Dining*, National Trust, London, 1993, p. 102.
5. Gerard, *The Herball*, pp. 1260–61.
6. Hilary Spurling, *Elinor Fettiplace's Receipt Book: Elizabethan Country House Cooking*, Viking, Harmondsworth, 1986, p. 112.
7. Gerard, *The Herball*, pp. 1130–33.
8. Ibid., p. 243.
9. Spurling, *Elinor Fettiplace's Receipt Book*, p. 97.
10. William Lawson, *A New Orchard and Garden*, London, 1623, p. 55.
11. Gerard, *The Herball*, pp. 614–16.
12. Ibid., pp. 872–3.
13. Richard Gardiner, *Instructions for Kitchin Gardens*, London, 1603, sig. D3.
14. Thomas Dawson, *A New Book of Cookerie* in *The Good Huswifes Jewell*, London, 1596, p. 28.
15. William Lambarde, *A Perambulation of Kent*, repr., London, 1826, p. 223.
16. Parkinson, *Paradisi in Sole*, p. 402.
17. Spurling, *Elinor Fettiplace's Receipt Book*, p. 133.
18. Gerard, *The Herball*, pp. 935–6.
19. Quoted in Paul Dinnage, *The Book of Fruit and Fruit Cookery*, Sidgwick & Jackson, London, 1981, p. 84.
20. Gerard, *The Herball*, pp. 122, 153.
21. Ibid., pp. 116, 111.
22. Mark Allen and John H. Fisher, eds, *The Complete Poetry and Prose of Geoffrey Chaucer*, Wadsworth, Boston MA, 2012, p. 621, ll. 44–48.

23. Gerard, *The Herball*, p. 512.

24. Ibid., pp. 269–70.

25. Ibid., p. 1088.

26. Ibid., pp. 1327–8.

27. Ibid., p. 1143.

28. Spurling, *Elinor Fettiplace's Receipt Book*, p. 124.

29. Gerard, *The Herball*, pp. 1250–51.

30. Philip Stubbes, *Anatomy of Abuses*, London, 1583, p. 49.

31. Thomas Hill (Didymus Mountain), *The Gardeners Labyrinth*, London, 1577, pp. 22–3.

32. Gerard, *The Herball*, pp. 744–5.

33. Ibid., p. 45.

34. Ibid., pp. 203, 804.

35. Ibid., pp. 146–7.

36. Ibid., p. 167.

37. Quoted in Geoffrey Grigson, *The Englishman's Flora*, Paladin, London, 1975, p. 464.

38. Gerard, *The Herball*, pp. 280–81.

39. Ibid., pp. 599, 604.

40. Quoted in Paston-Williams, *The Art of Dining*, p. 121.

41. Gerard, *The Herball*, p. 1266.

42. Dawson, *A New Booke of Cookerie*, p. 33.

43. Hugh Platt, *Floraes Paradise*, London, 1608, p. 80.

44. Gerard, *The Herball*, pp. 1168–9.

45. Ibid., p. 1158.

46. Ibid., pp. 704–5.

47. Dawson, *A New Booke of Cookerie*, p. 6.

48. Gerard, *The Herball*, p. 1267.

49. Ibid., p. 298.

50. Book 2, Canto VII, Stanza 51; in Edmund Spenser, *The Faerie Queene*, ed. A.C. Hamilton, Pearson, London, 2001, p. 221

51. Gerard, *The Herball*, p. 781.

52. Ibid., pp. 774–5, 765.

53. Dawson, *A New Booke of Cookerie*, p. 26.

54. Ibid., p. 37.
55. Gerard, *The Herball*, p. 1264.
56. Ibid., p. 1114; pp. 317–8.
57. Ibid, pp. 1077–84.
58. Platt, *Floraes Paradise*, p. 30.
59. Gerard, *The Herball*, p. 1110.
60. Ibid., p. 1071.
61. William Harrison, *The Description of England*, ed. Georges Edelen, Dover, New York, 1994, pp. 350–51.
62. Gerard, *The Herball*, pp. 124–6.
63. Ibid., pp. 427–8.
64. Tusser, *Five Hundred Pointes of Good Husbandrie*, p. 34.
65. Gerard, *The Herball*, p. 845.
66. Quoted in Paston-Williams, *The Art of Dining*, p. 59.
67. Gerard, *The Herball*, pp. 538–40.
68. Ibid., pp. 698–701.
69. Spurling, *Elinor Fettiplace's Receipt Book*, p. 98.
70. Dawson, *A New Booke of Cookerie*, p. 29.
71. Gerard, *The Herball*, pp. 1251–2.
72. Ibid., p. 936.
73. Tusser, *Five Hundred Pointes of Good Husbandrie*, p. 123.
74. Gerard, *The Herball*, p. 946.

Further reading

Barnard, John, 'Politics, Profits and Idealism: John Norton, the Stationers' Company, and Sir Thomas Bodley', *Bodleian Library Record* 17 (2002), pp. 385–408.

Ellacombe, Henry Nicholson, *The Plant-Lore and Garden-craft of Shakespeare*, Exeter, 1878.

Grigson, Geoffrey, *The Englishman's Flora*, London, 1958.

Law, Ernest, *Shakespeare's Garden*, Stratford-upon-Avon, Oxford, 1922.

Mabey, Richard, *Flora Brittanica: The Definitive New Guide to Wild Flowers, Plants and Trees*, London, 1996.

Singleton, Esther, *The Shakespeare Garden*, New York, 1922.

Spurling, Hilary, *Elinor Fettiplace's Receipt Book: Elizabethan Country House Cooking*, London, 1986.

Stobart, Tom, *Herbs, Spices and Flavourings*, London, 1970.

Willes, Margaret, *The Making of the English Gardener: Plants, Books and Inspiration, 1560–1660*, New Haven CT and London, 2011.

Picture credits

Index